MONHEGAN COME AGAIN

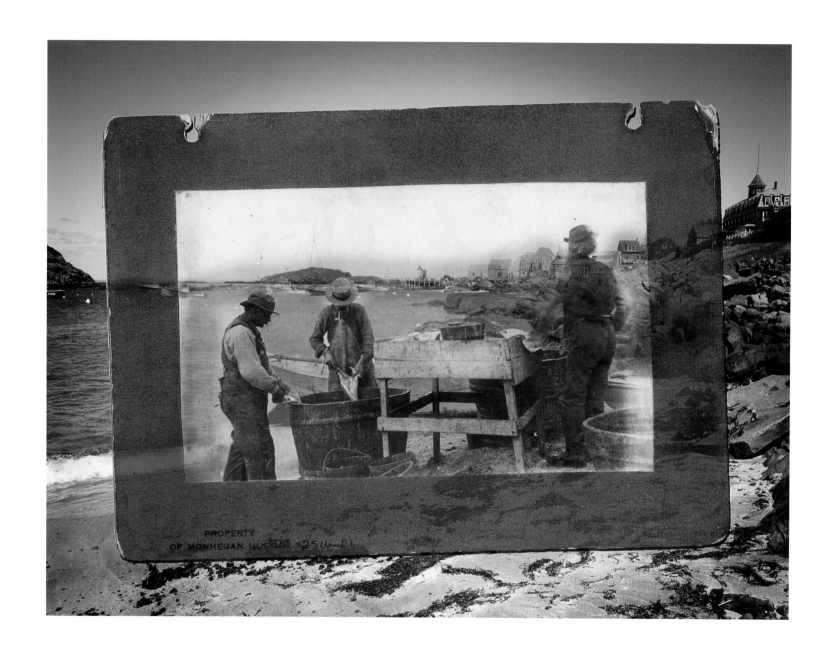

Gutting Table

MONHEGAN COME AGAIN

Looking through the past to the present

RICHARD W. MOORE

Pawtuckaway Publishers
Deerfield, New Hampshire

Pawtuckaway Publishers
Deerfield, New Hampshire 03037

Moore, Richard W.
Composites of vintage and contemporary
photographs from the same locations on
Monhegan Island, Maine.

ISBN 978-0-615-96354-9

Vintage photographs courtesy of the
Monhegan Museum.

THIS WORK IS DEDICATED TO
THE COMMUNITY OF MONHEGAN ISLAND.

CONTENTS

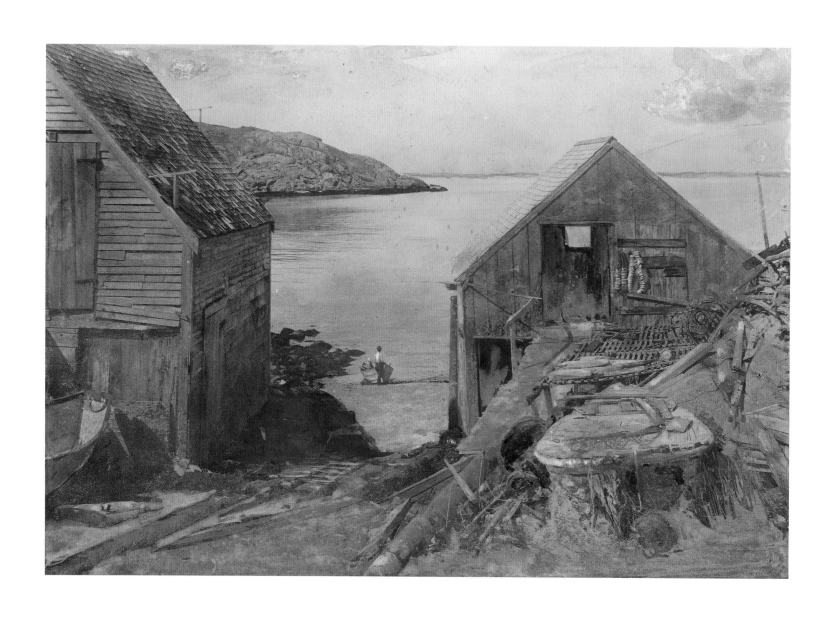

Overpainted photograph of Starling Cove by S. P. Rolt Triscott

FOREWORD

Four hundred years ago the celebrated English explorer Captain John Smith visited Monhegan and Manana Islands. These islands, sixteen miles from the mainland, were already well known to Native Americans and European fishermen as rocky outposts in the middle of the sea. Monhegan's role as an early fishing station evolved into that of a year-round fishing village after the American Revolution. So it was when this island village was first "discovered" by artists and photographers in the late 1850s.

The elemental lives of the fishing families, played out against Monhegan's richly varied topography, captured the imaginations of post-Civil War painters and picture-takers. Among the artists who came to the island from Boston were S. P. Rolt Triscott (1846-1925) and Eric Hudson (1862-1932). Born and trained in England, Triscott was a highly accomplished watercolor painter who first visited Monhegan in 1892 and settled here permanently a decade later. Hudson, who worked primarily in oils, arrived on Monhegan in 1897. He built a cottage here the following year and returned each summer until his death. The discovery of Monhegan was an epiphany for both men, one which they celebrated by photographing the island's harbor and village life and its dramatic natural features. Triscott used many of his photographs as the basis for his watercolors.

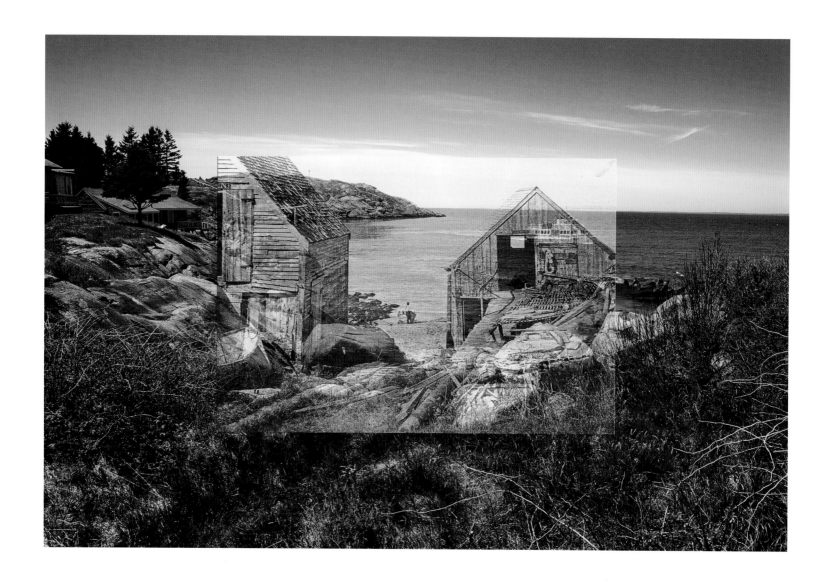

Starling Cove

Triscott also produced photographic prints to sell, some of which he over-painted in watercolors and others that he toned in sepia. Hudson's photographs were made largely for their own sake, as a record of a beloved place.

More than a century after Triscott and Hudson recorded impressions of Monhegan with their cameras, Richard W. Moore has created a fascinating body of photo composites of the island by combining historic photographs—among them Triscott's and Hudson's—with his own.

In *Monhegan Come Again*, Moore explains that we are "looking through the past to the present"—but Moore's looking glass often works both ways. Through his magical picture of the present-day harbor from Manana, at the center of which is carefully superimposed the earliest topographical photograph of the village, we experience the effect of looking into the past through an opening in the present. Many of the images that combine past fishermen and villagers with present-day scenes have a ghostly quality suggesting the simultaneous existence of two dimensions. There is a haunting beauty about these photographs that allows us to move easily between two worlds and underscores the timelessness of Monhegan.

In Moore's photographs we rediscover the truth in Ralph Waldo Emerson's words: "the Past will not sleep, it works still."

Earle G. Shettleworth, Jr.
Maine State Historian

INTERSECTING VISIONS

DOUGLAS D. PRINCE

I look at photographs in two stages. My first response to a photograph is, of course, visual: nonlinear, intuitive, multilayered and complex. This is an emotional response to the subject matter, to the image-making processes used and the context in which the image is being viewed. Good photographs can generate a wide range of experiences: they can elicit joy or be disturbing, insightful, ambiguous, humorous or sad; or any combination of the above. This is the core of the joy of looking at photographs. Not all photographs reach this level of connection with their viewers. But when they do, you—as the viewer—really sense that you have been touched by the photographer's vision.

The second stage of response is a more literal analysis of the elements that go into making the image. This is an analytical response to the first visual reaction to the image, an attempt to explain how that emotional experience is created. While the words in an essay or critical response to a photograph are not a substitute for the visual experience, they do serve to expand our understanding of the photographer's vision and our appreciation of the craft.

Photographic images are built with three basic building blocks: light, time, and space. The photographer uses light to define forms and textures and contribute to the emotional content of an image. The photographer deals with time, from multiple and long exposures to stop-action photography.

And, the photographer explores the elements of space, from the two dimensions of flat abstractions to the dynamic juxtaposition of elements in a three-dimensional reality.

Anyone looking at images in *Monhegan Come Again* will immediately recognize that Richard Moore is combining photographs from the past with photographs from the present to make his composites. This is a particularly photographic form of hybrid imaging, and Moore is one of its most accomplished practitioners.

When viewing the intersection of images taken more than one hundred years apart, we need to consider the impact of 19th-century and 21st-century photographic media. S. P. Rolt Triscott used the materials contemporary to his time: a large-format view camera on a tripod with glass plates that made black-and-white negatives which were then made into paper prints. Moore is using photographic processes of his time: a digital camera (though still on a tripod) that generates images in color that can be shared electronically, printed on paper or presented in a book.

These are important distinctions to make not just because of the way in which information is recorded and distributed, but also because of the ways in which those different media create the ambience and flavor of the cultures that they capture. Since we did not actually experience the 19th century first-hand, photographs function as a collective memory of that period. This "collective memory" of the 19th century is highly influenced by the nature of the photography of that period: the static presentations and monochromatic qualities recorded on glass plates and in albumen prints.

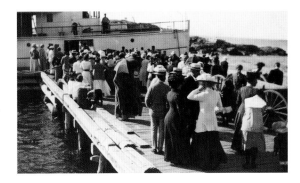 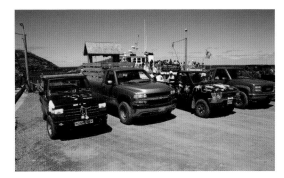

I remember the first time I saw a collection of quilts from the 1880s. I was amazed at the variety and richness of colors and textures. In my "memory" of that time—generated by photographic images—I had always seen people wearing shades of gray, which influenced my impression of the "flavor" of the times.

Starting with selected images from the Monhegan archives, Moore explored the sites where contemporary landscapes and activities revealed insights into the passage of time. He has very carefully maintained the continuity of spaces, using them as a stage to review the dramatic changes that have occurred over time.

While the geology of the island remains relatively constant, there have been some remarkable transformations in the cultural environment. These changes are seen in the activities and costumes and structures of the island's inhabitants. The impact of this juxtaposition of past and present ranges from the ironic and humorous to the sobering and insightful.

Moore takes full advantage of the digital tools available to integrate these images. Sometimes the past and present images are simply digitally layered over each other with color and transparency used to meld the two time periods.

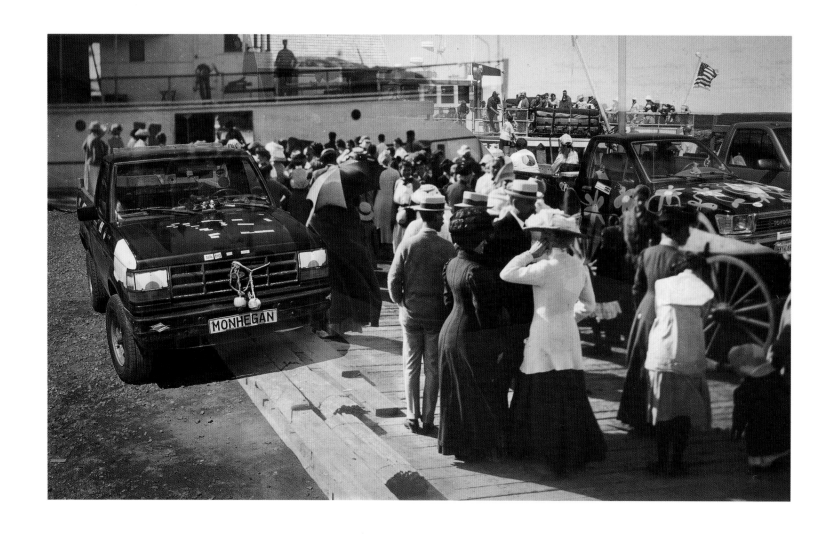

A Welcoming Bustle

Many images are combined with the frame of one image inserted into the other, with variations of color and transparency. This helps the viewer weave the events and spaces together. In other images, the frame of the original picture is visible, reinforcing the evidence of the photograph as object and helping the viewer to sort the past from the present.

Moore has generated a wide range of emotional reactions: from simple ironies, such as the present-day children stopped as they run past the class posing in front of the school (p. 79) or more provocative, anthropological observations of culture and costumes (left). These contrasting environments, so closely commingled, make us acutely aware of the passage of time and of changes in our social landscape.

Moore is an astute observer of place and a skilled time-traveler. Through his images, we witness both the inexorable tide of time and the constancy of the human spirit.

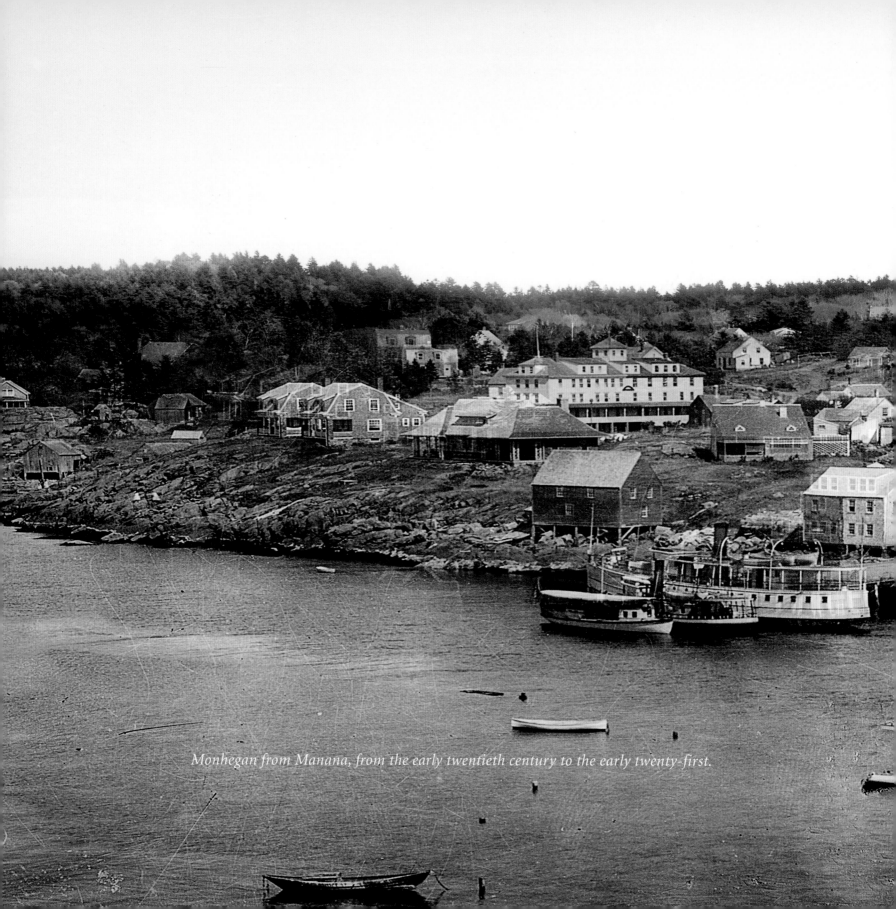

Monhegan from Manana, from the early twentieth century to the early twenty-first.

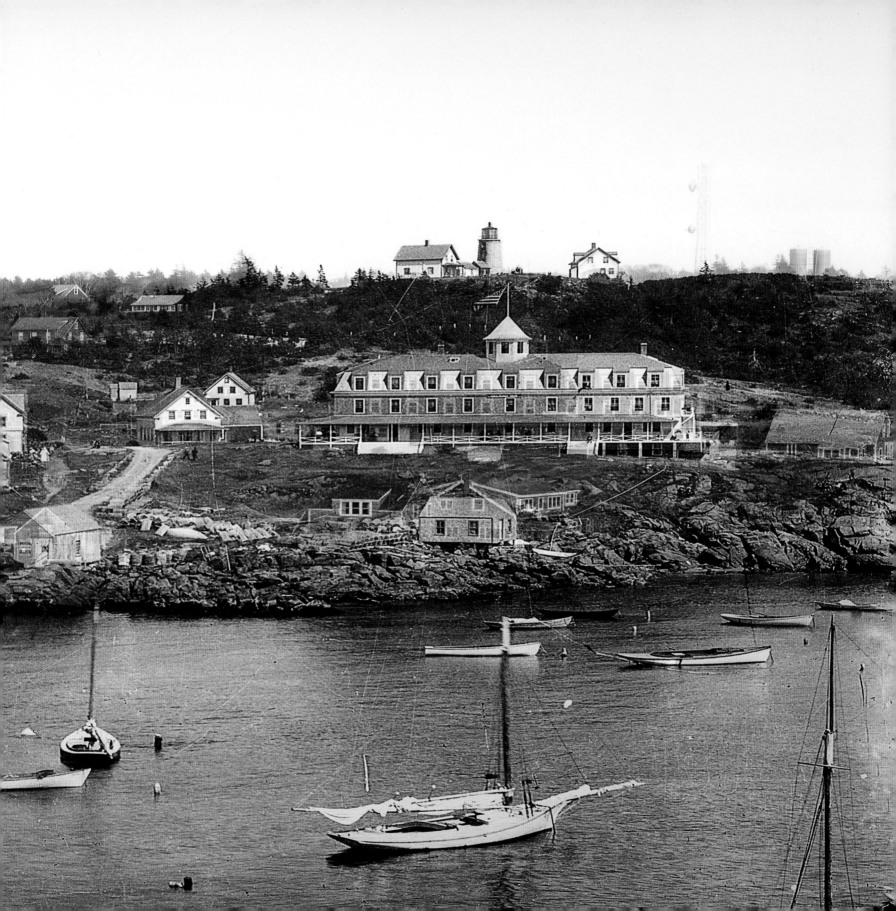

MONHEGAN COME AGAIN

RICHARD W. MOORE

QUADRICENTENNIAL

The images in this book are composites of photographs from two different eras, a century apart, captured in the same location. I look at the present through the past.

The occasion for the book is the 400th anniversary—the quadricentennial —of Captain John Smith's landing on Monhegan Island in the spring of 1614. He and his crew planted a garden, built some boats, tried whaling, dried some fish, scouted around for gold, and sailed away before winter set in. But British fishing boats began coming the next year; and by the following decade, Smith wrote, eighty British ships had visited Monhegan. For three hundred years the island would attract a growing fishing fleet and, eventually, a small year-round community.

One hundred years ago, in 1914, the 300th anniversary—the tercentennial— of John Smith's landing was celebrated with bunting and bustles and a coronet band. That era was the heyday of the artists who had recently colonized the island—George Bellows played the snare drum in the band; Edward Hopper and Sears Gallagher had paintings in the art exhibit, and young Rockwell Kent had already come and gone (to return later).

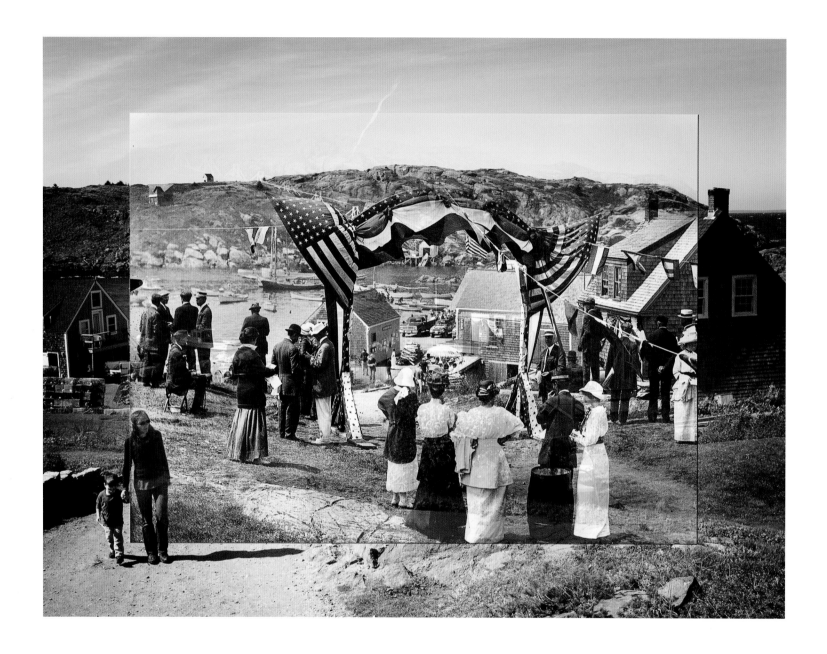

The Arrivals

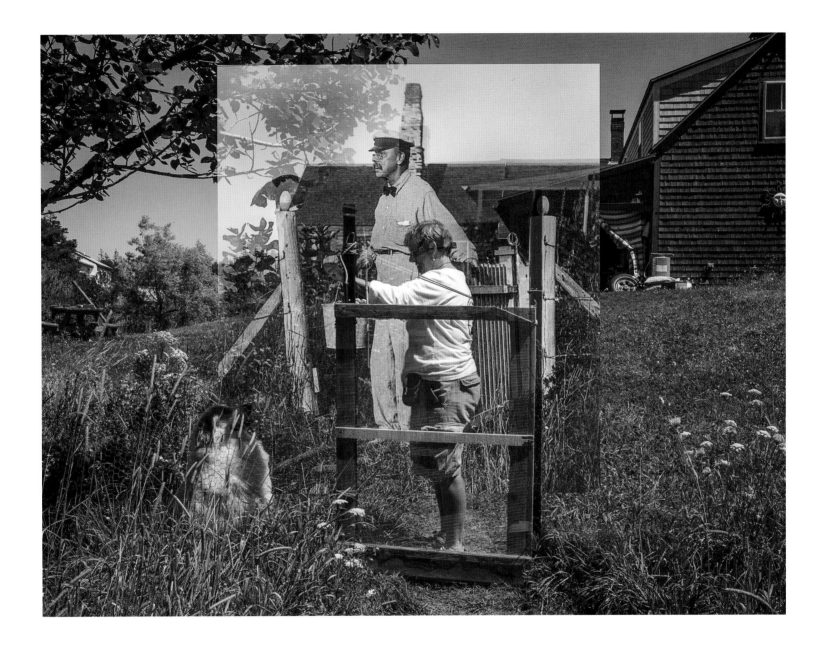

Triscott's Gate

The watercolorist and photographer S. P. Rolt Triscott, who visited the island beginning in 1892 and then moved here permanently, attended the tercentennial celebration and had watercolors in the art exhibit. His photographs, mostly from 1900 and earlier, were the first inspiration for this book. The great-niece of Triscott's life-long housekeeper now owns his house.

Each summer brings tens of thousands or more visitors to the island, seeking glimpses of the storied past of Monhegan in its present life. The merging of photographs from two eras can serve as a map for that quest.

In the course of making this book I studied hundreds of vintage photographs from the Monhegan Museum and set about to identify, as closely as possible, the original camera locations. I met as many people as I could, without invading their resolute Monhegan reserve. Crews on the boats, people at church, at the museum, in their gardens. The workers and sternmen, captains and innkeepers.

I made a small book of the vintage images, with pencilled-in grid lines and marks on the photos, identifying clues that might lead me to the original camera locations—rocks and ledges that don't move much, old buildings that often do. Then I followed my book around the village, up and down the main road, revisiting the beaches, the wharf, the library, the museum, back and forth, looking for the right light, the right tide, the right...something.

I made thousands of contemporary images over the course of a year, and hundreds of trial composites. I had good days and bad days. I met extraordinary people. The ability to see the past and the present merge, not only in the image, but in the life of the community, is the great gift offered by Monhegan.

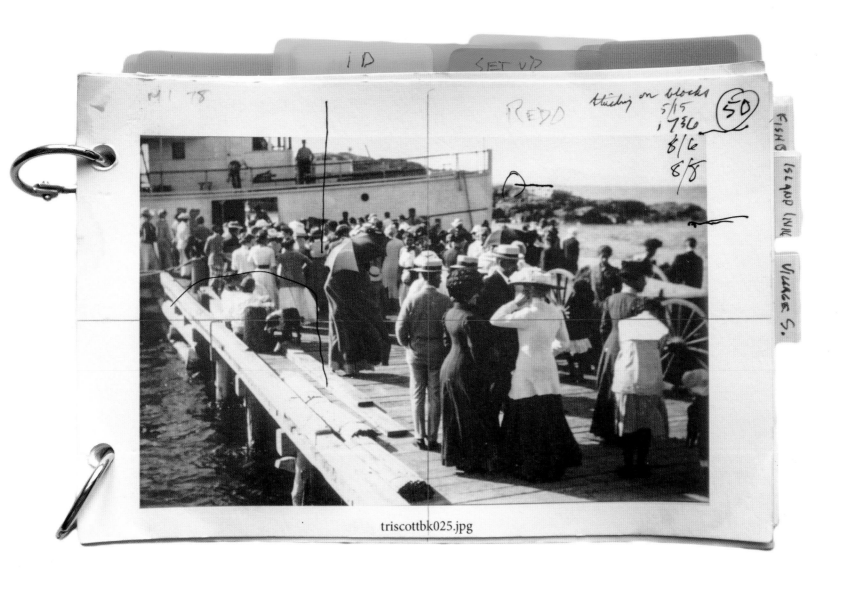

triscottbk025.jpg

"I made a small book of vintage images..."

THE *EFFORT*

From the 1880s until 1907, the mail, supplies, and the summer visitors — "rusticators," as they were known on the island—were delivered by Captain Will Humphrey on board the packet schooner *Effort*. According to marine historian W. H. Bunting, Humphrey bought the *Effort* out of Massachusetts Bay, where she had served as a pilot boat—capable of delivering a pilot to a ship and returning with only two sailors aboard. On occasion, Humphrey even sailed her by himself. Once he was sailing alone and became becalmed. He noticed a timber floating nearby and, thinking he could put it to use, set out in the skiff to retrieve it, whereupon the wind came up and the *Effort* sailed away without him. Humphrey rowed for seven miles before finally snagging the schooner with the boat hook and getting back on board.

In the early 1900s a passenger dropped a match down the hatch and ignited the fumes of *Effort*'s new gas engine. Though the details are not known, Captain Humphrey took retirement, and the new steamship *May Archer* took over the task of deliveries to the island. The pilot boat *Effort*, says Bunting, likely had another life, perhaps as a sardine transport, "because they were fast, you know."

OPPOSITE: The *Effort* coming into the south end of Monhegan Harbor. On the following pages, she goes out "the back door" by the dock and later lies beached —careened for cleaning—on Fish Beach.

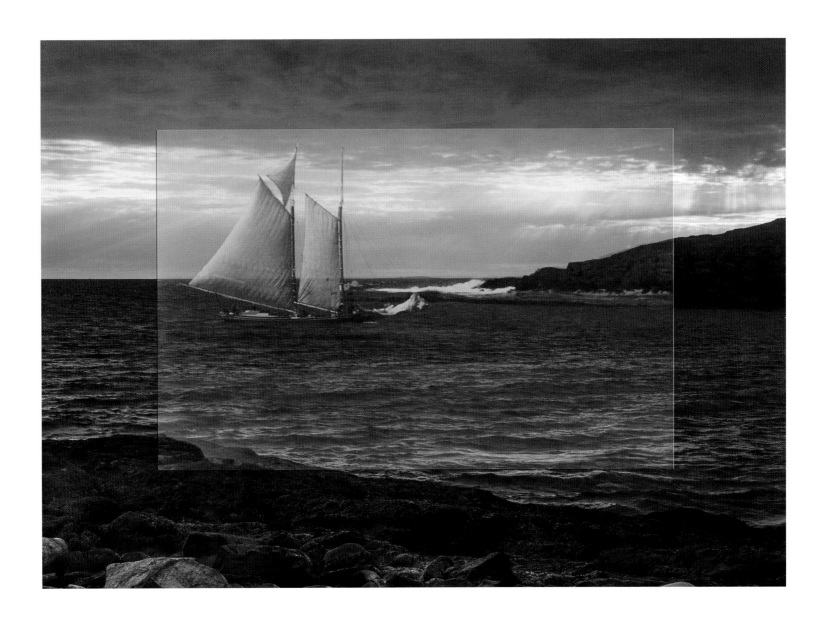

The Effort

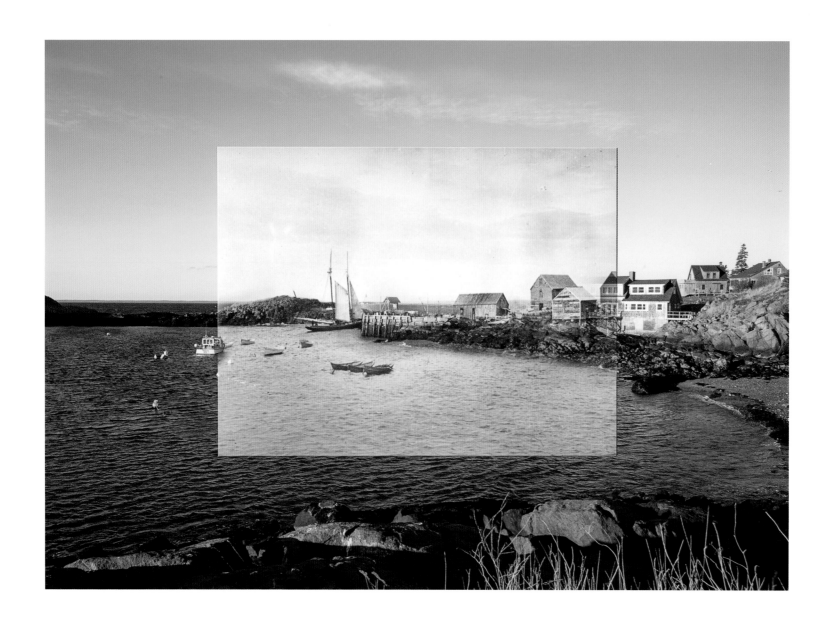

Out the Back Door

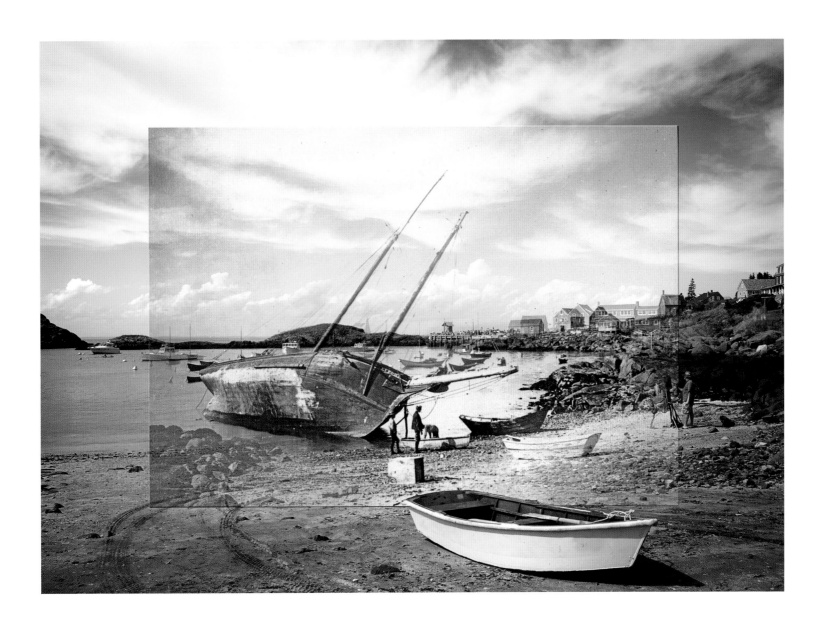

Effort *Careened*

WELCOME BACK

Island people and visitors alike have been greeted by horse and carriage, pickup truck or golf cart, stranger or neighbor or worker; sometimes with an accordion and a song; with hearty joy and the solemn acknowledgment of time's passage.

There are eight hundred beds on the island. In the summer, most of the beds are full most nights. In the winter, one boat comes to Monhegan three times each week. In the summer, five boats come multiple times each day, from Port Clyde, Boothbay Harbor, and New Harbor. Day-visitors come off the dock in waves, trying to take it all in, taking pictures of everything; receding at the end of the day. Sometimes they come by the thousands. By evening, the village is quiet again.

There's a small church, served by visiting clergy and the century-old Maine Sea Coast Mission. But the main gathering place is the dock. Everyone goes to meet the mail boat, to see who's coming and going, to share news, unload supplies and baggage from the boat and load empty propane tanks and bags of recycling.

"We have our own way of doing things," says an islander. "It's not the law, it's oral tradition. Nothing is written down." For example, there are no pubs on the island. Never have been, never will be. Well, there is that new micro-brewery's "tasting room;" but that, the community has decided, is different.

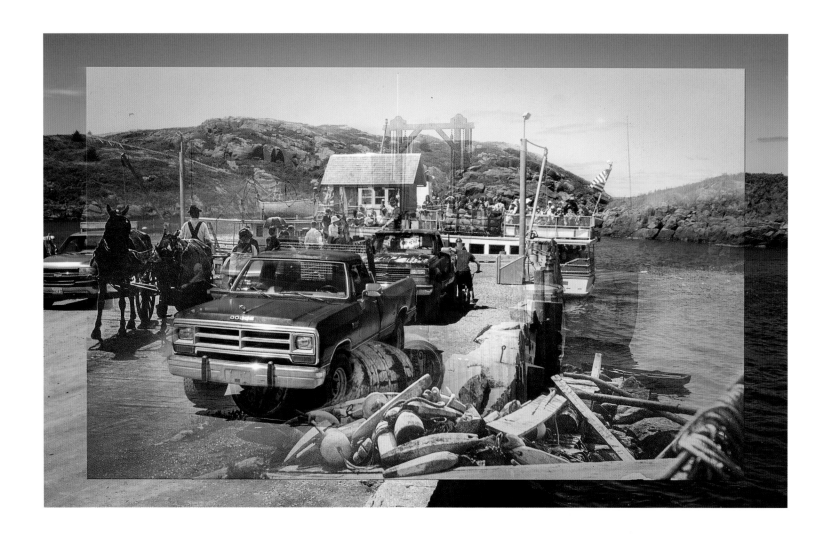

The Greeting

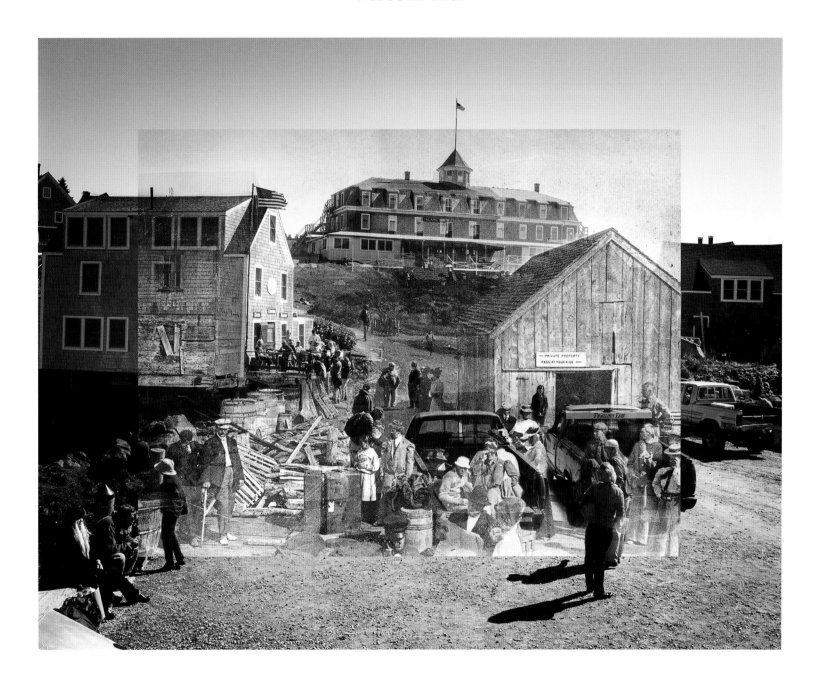

End of the Season

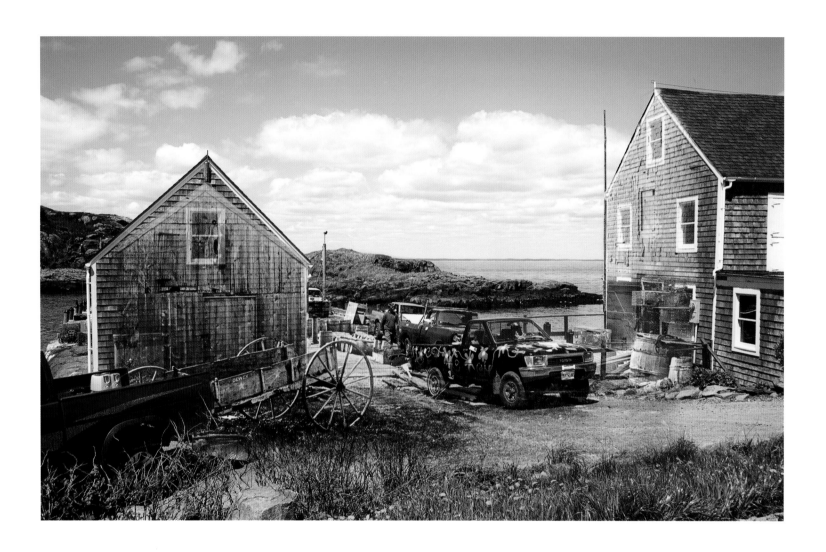

Trucking

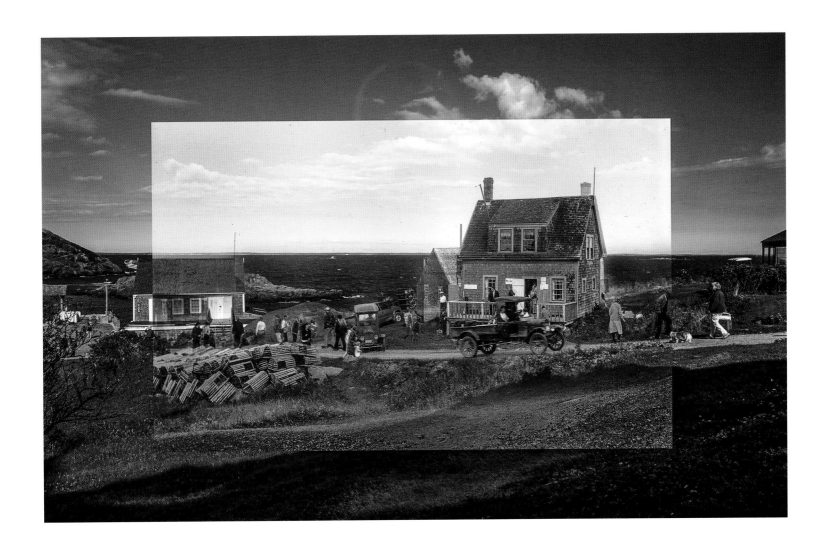

The Road by Uncle Henry's

The John Sterling House, at the top of the hill, was the post office in 1914. I approached a woman in the garden to ask permission to make a photograph, and I showed her the vintage photo of the postmaster. "Oh yes," she said, "that's my grandfather."

 "Nearly all the island families are related, through marriage or descent, and existence on the island is full of event."
—*Boston Evening Transcript*, Aug. 21, 1897

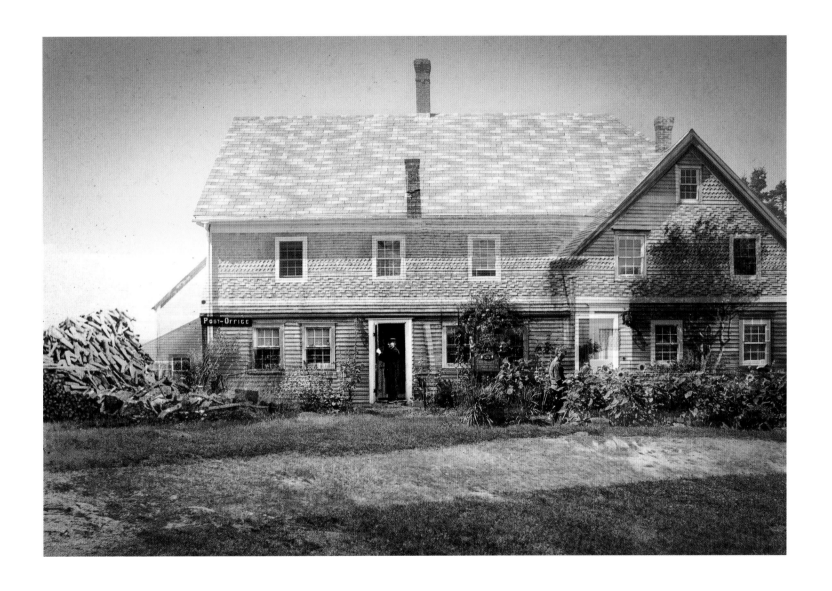

John Sterling House

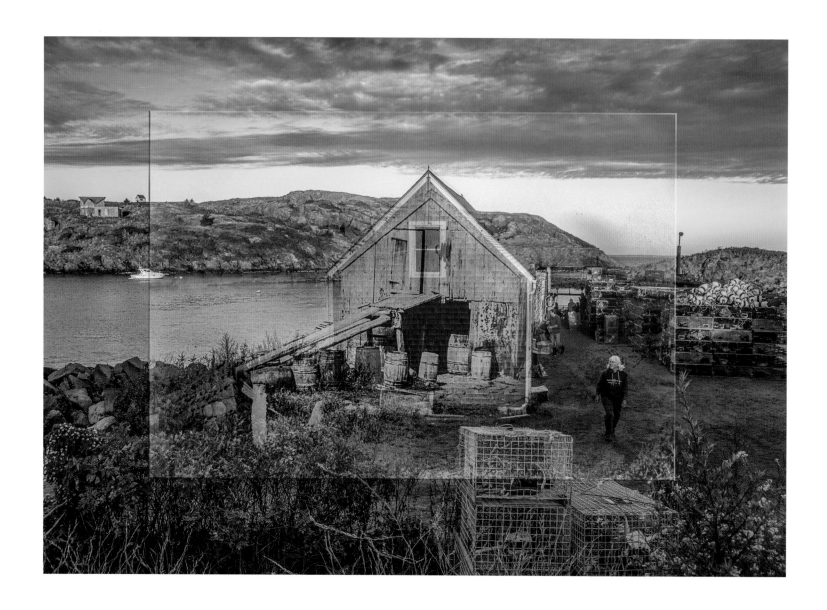

Trap Day Dawn

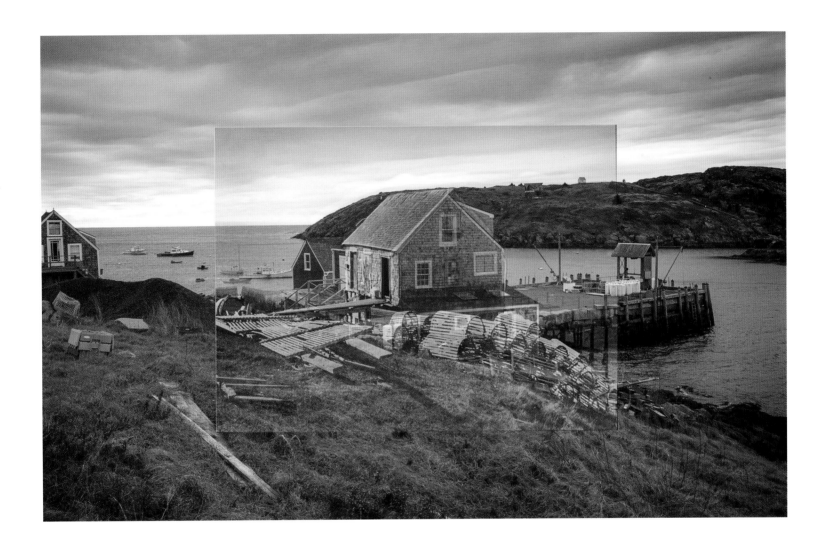

Off-season

Charles Jenney, author of *The Fortunate Island of Monhegan*, wrote of the islanders who came to Monhegan in the 1800s, "These families did not live in an inconvenient or inaccessible place. They were upon the great highway of the ages."

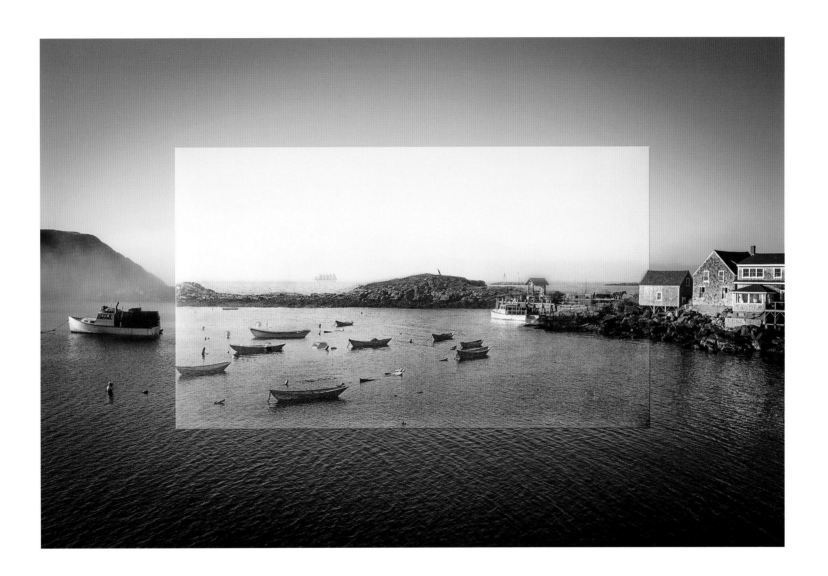

Trap Day Eve

THE FISHERMEN'S ISLAND

The Thomas Horn Fish House, built in the 1780s, is the oldest structure on the island. For the last several generations it has been owned by the Stanley family, and for as long as anyone can remember, the fishermen of Monhegan have convened on its second floor to debate who fishes, where and when and how, in the ever-changing world of an historic fishery.

A visitor wrote in 1887, "When the men are not abroad fishing or making preparations, they idly lie about the fish houses and upon the sand, watching the wind and waves." Today, Captain Shermie Stanley, current king of the fish house, is a lobsterman, the Monhegan harbormaster, propane deliverer, and chief cook and owner of the Fish House Cafe. Another lobsterman is also the busy local brewmaster. And, fortunately, the constable. It defies imagination to picture them "idly" lying about.

Lisa Brackett is Shermie's sternman, plus potato-peeler in the cafe, real estate agent, and storekeeper. "And," she says, "I'm a Brackett."

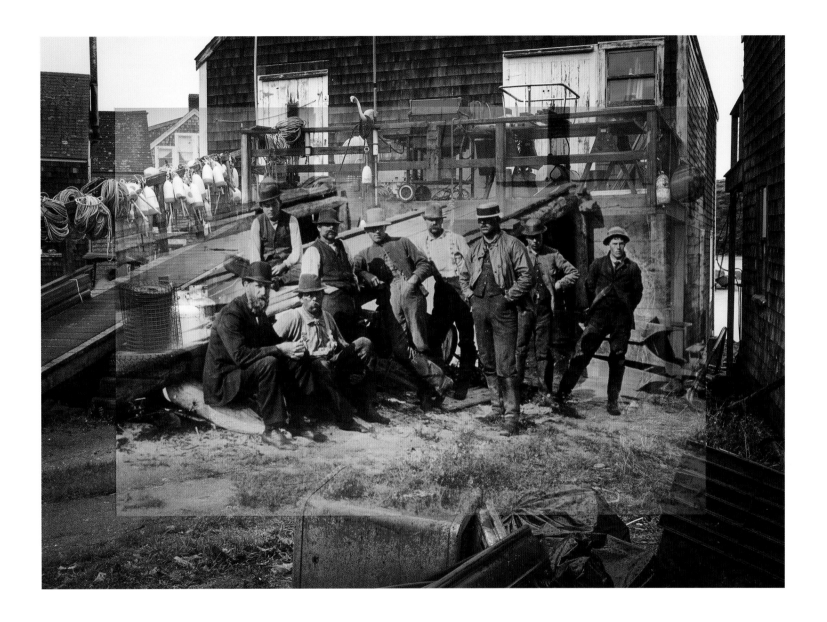

Fish House Men

"Boats, man. Fucking boats."

Would it be possible to get him and a few of the captains and sternmen together for a photo? I start to explain but he cuts me off. This young fisherman knows all about Rolt Triscott and Captain John Smith and the quadricentennial, in fact he is a painter himself, but there's no time. "Boats, man..." They're beaching out the boat today.

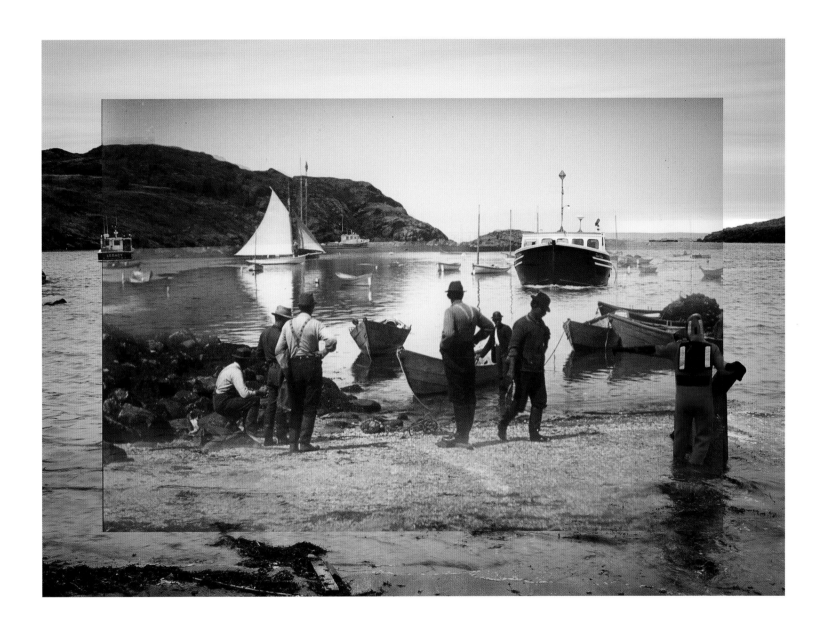

"Boats, Man"

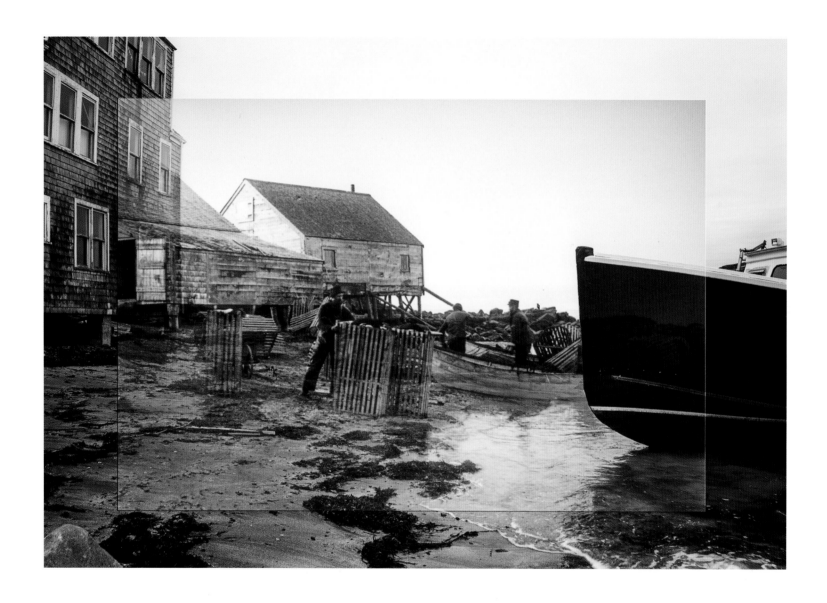

Face-off

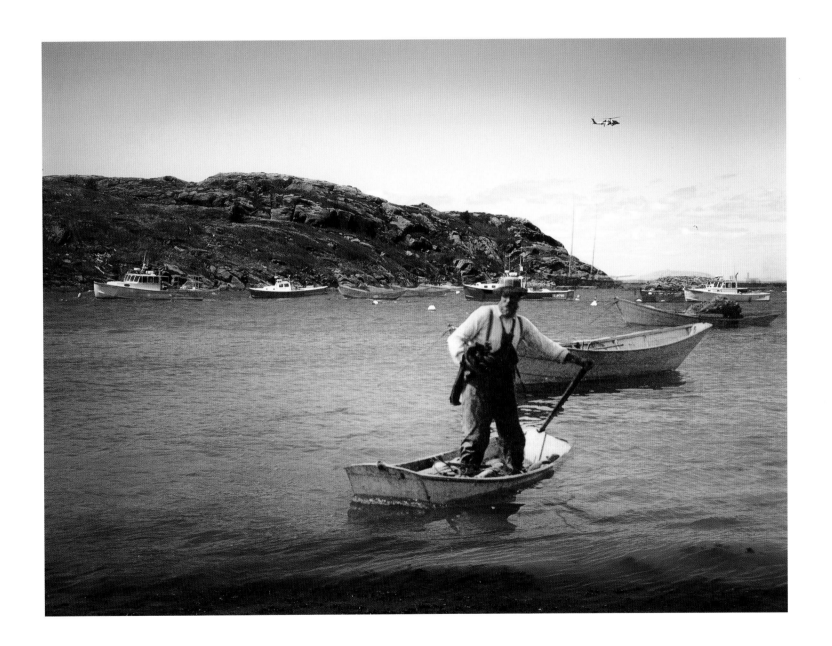

Sculling

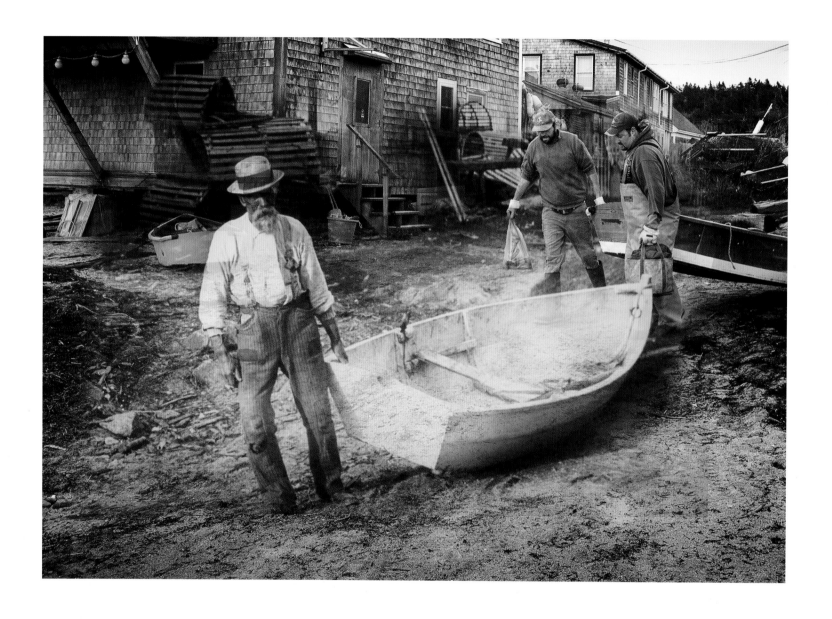

Going to Work

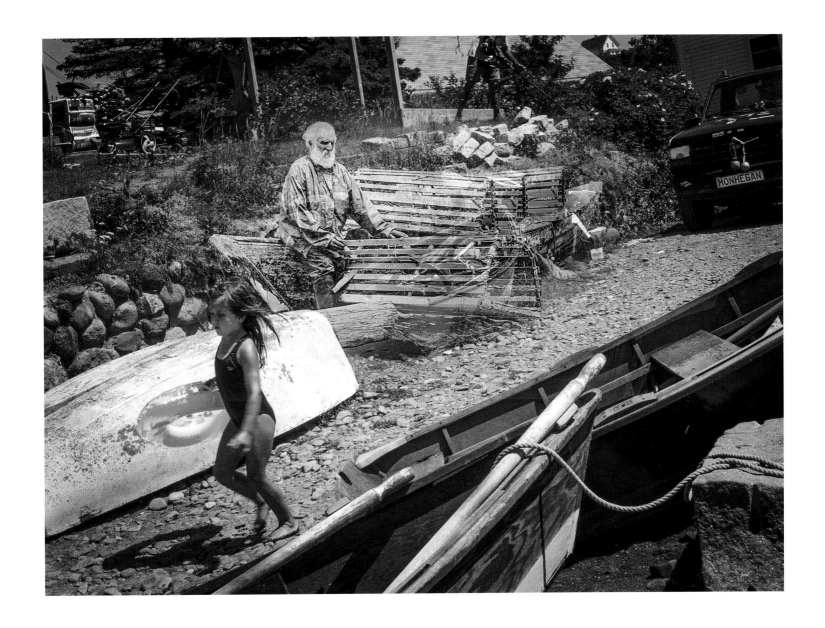

Swim Beach Road

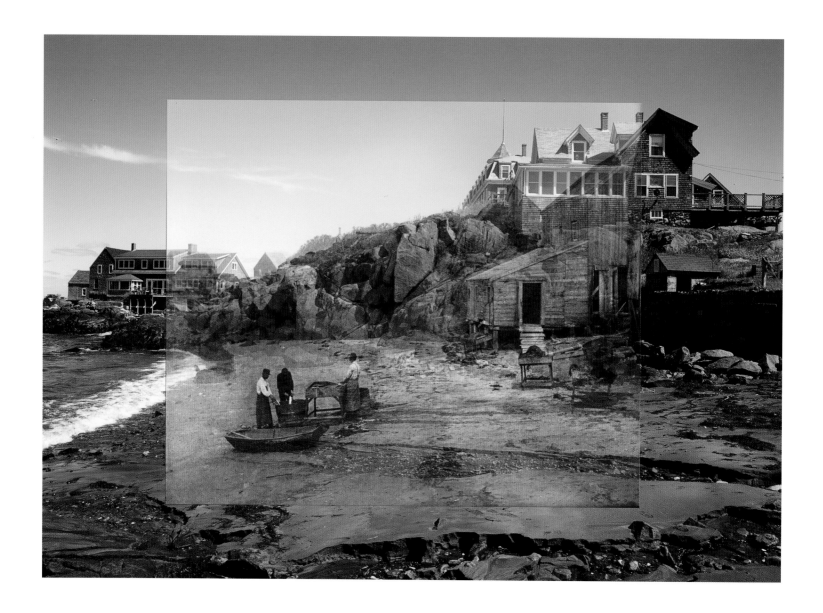

Cleaning Fish on Swim Beach

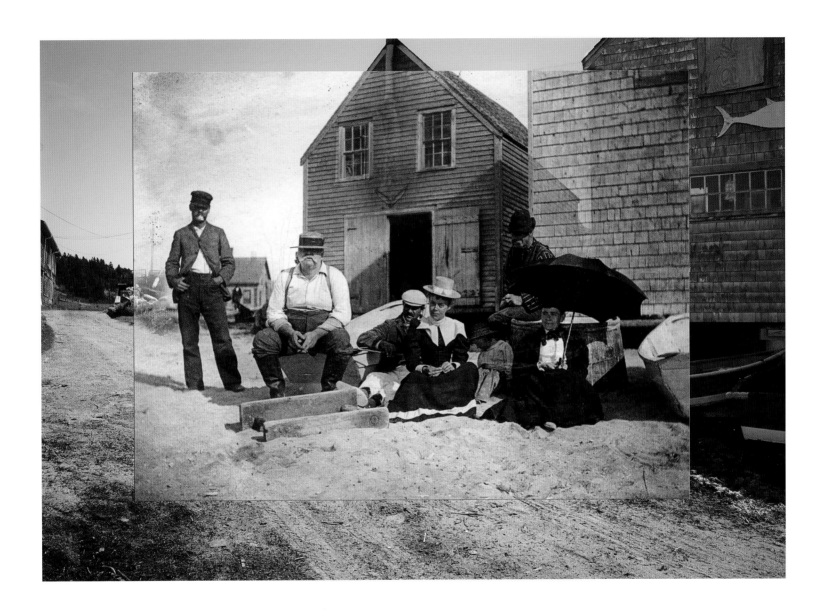

Lighthouse Keeper Dan Stevens and His Family

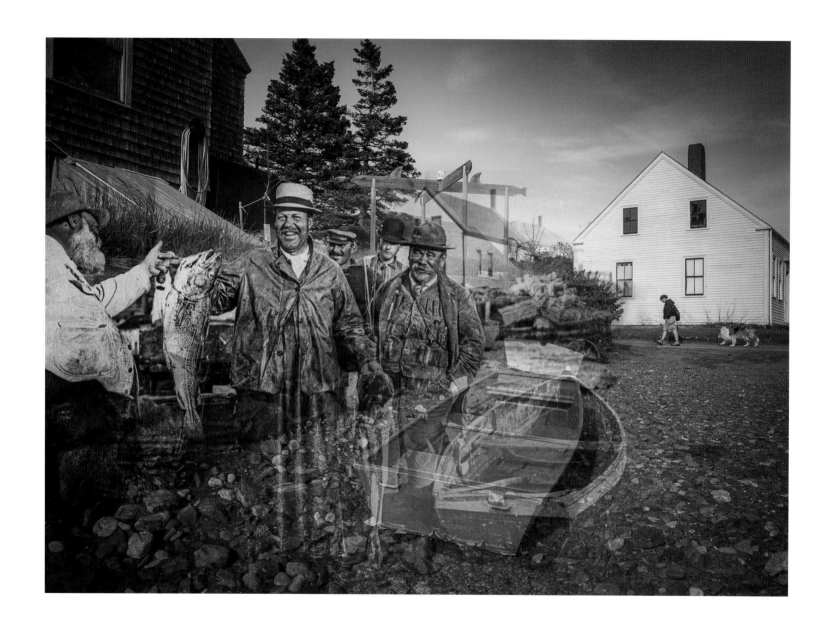

Sports

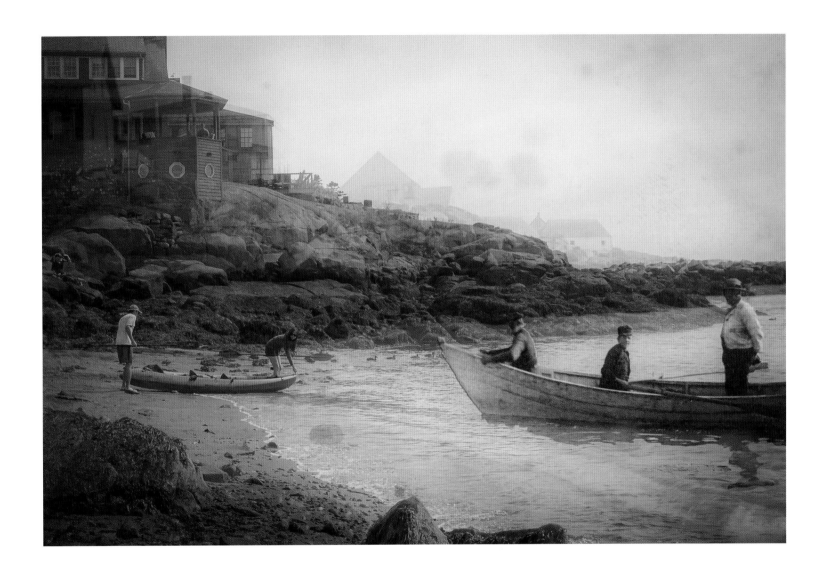

Dory and Kayak

Beautiful boats, working boats, forgotten boats. Some of the old Monhegan boat styles are known only from photographs. The centerboard sloops *(opposite)* were constructed with the mast far forward, to give the fisherman room to work. The boats could be easily beached by pulling up the centerboard.

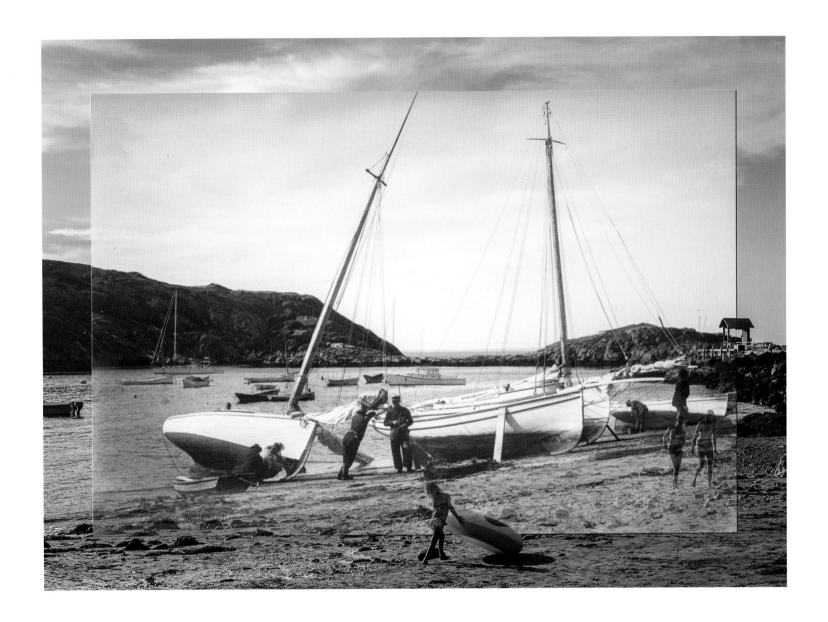

Centerboard Sloops

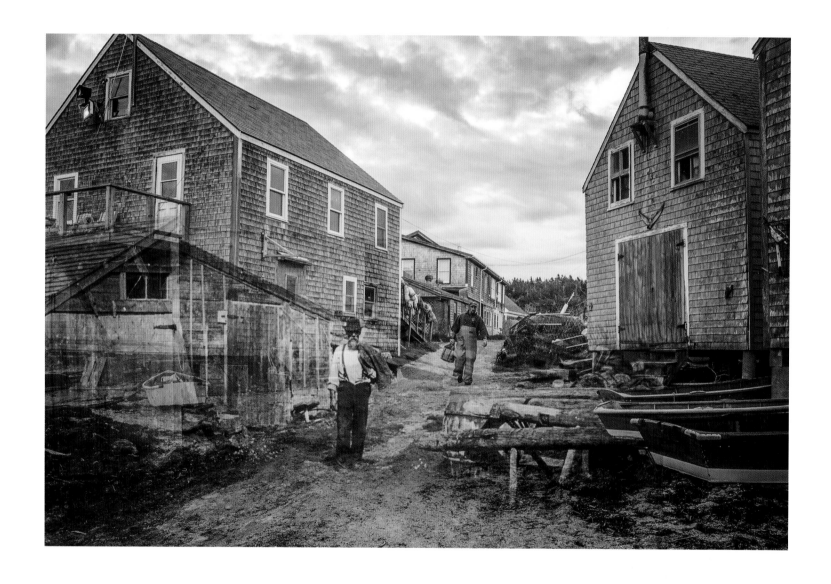

Fish Beach Road

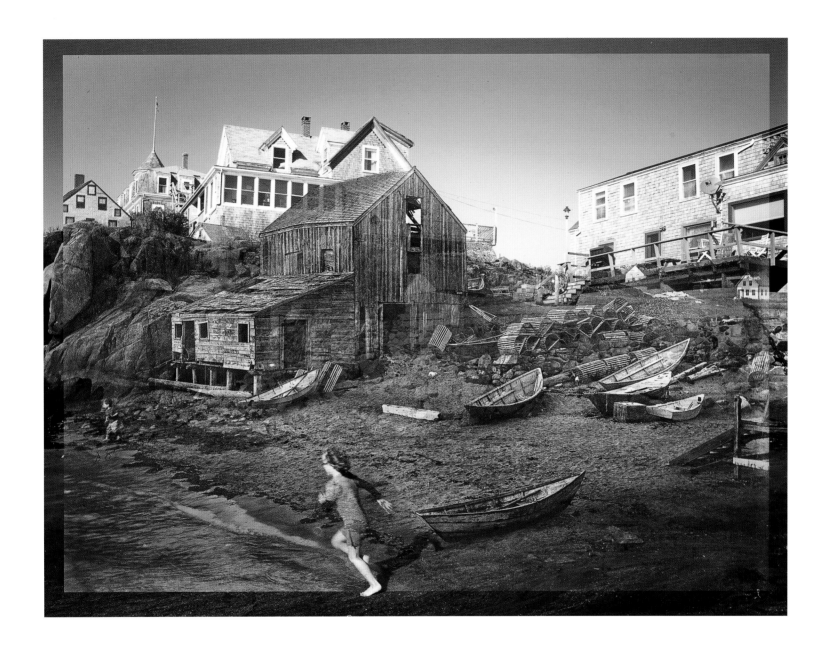

Swim Beach Dance

THE ARTISTS' ISLAND

Maybe it's the light that draws the artists here. The simplicity and force of the elements, the pull of tides. Maybe it's the habit of history, how the past dwells in the present. Manana and Monhegan face each other across a harbor, alter islands, twins separated at birth, mother and child. Maybe it's the duality of imagination, what is and what could be. Maybe it's the proximity of life to death. Or the condition of vulnerability.

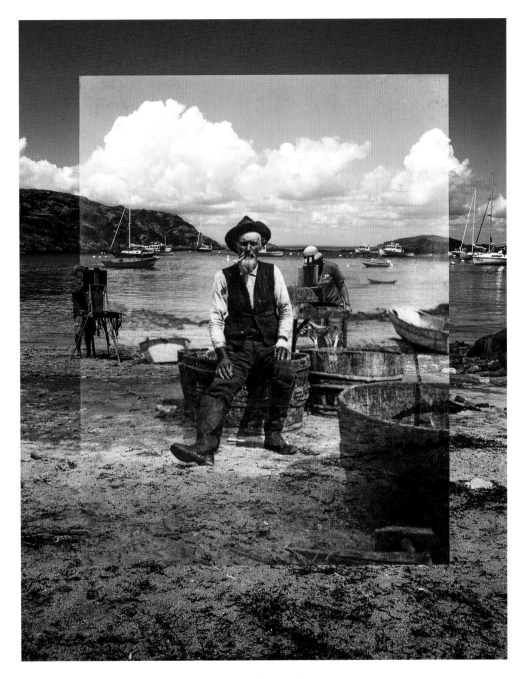

Portrait

The artists are related by paint if not by blood—Robert Henri to Edward Hopper, Sears Gallagher to Abraham Bogdanove, three generations of Wyeths; countless teachers and students.

Contemporary New Haven-based painter Frank Bruckmann "posed" with 19th-century Sears Gallagher; with Harrison Humphrey, the island blacksmith; and a cow. Bruckmann shows up in other composites not because I posed him in these places—he just seemed to be everywhere an old photo had been made.

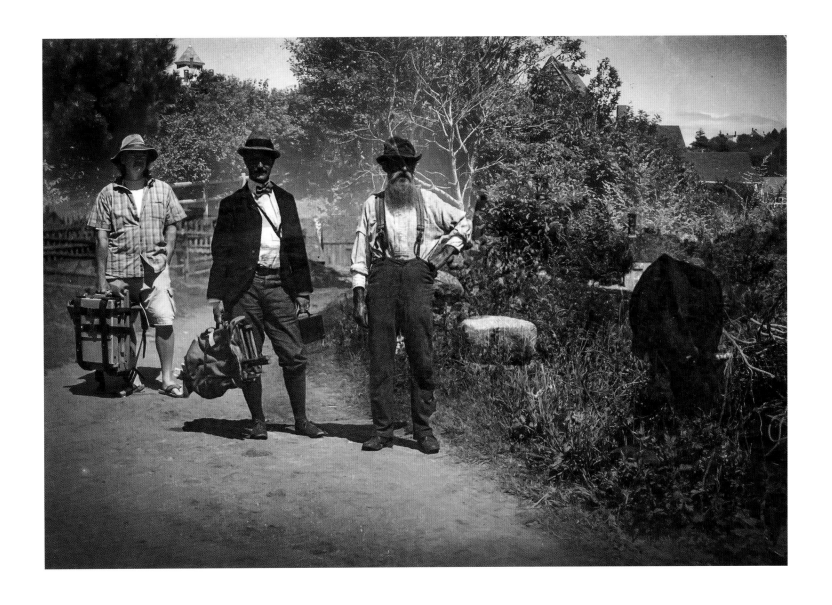

Bruckmann, Gallagher, & Humphrey

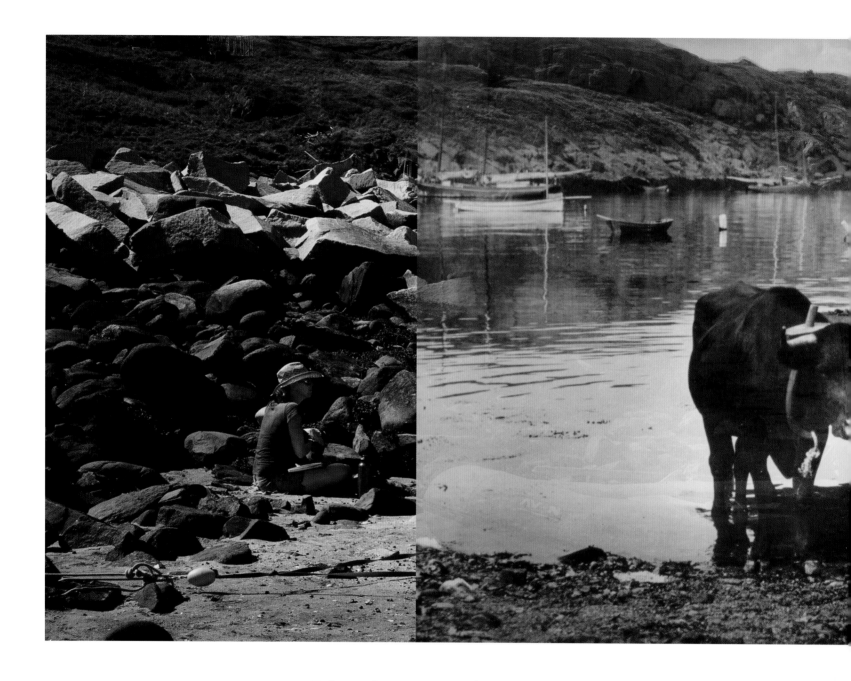

Fish Beach Panorama with Oxen

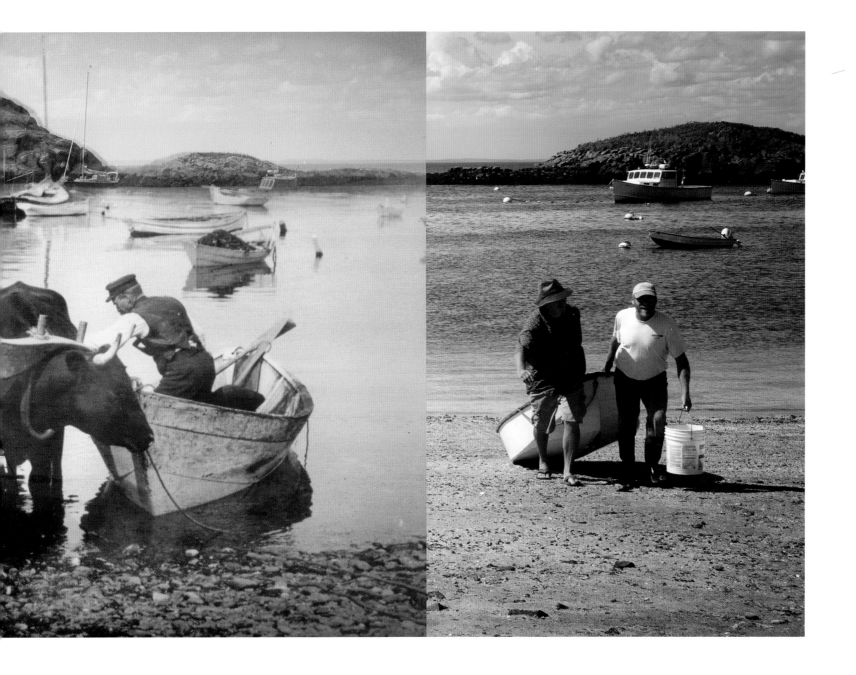

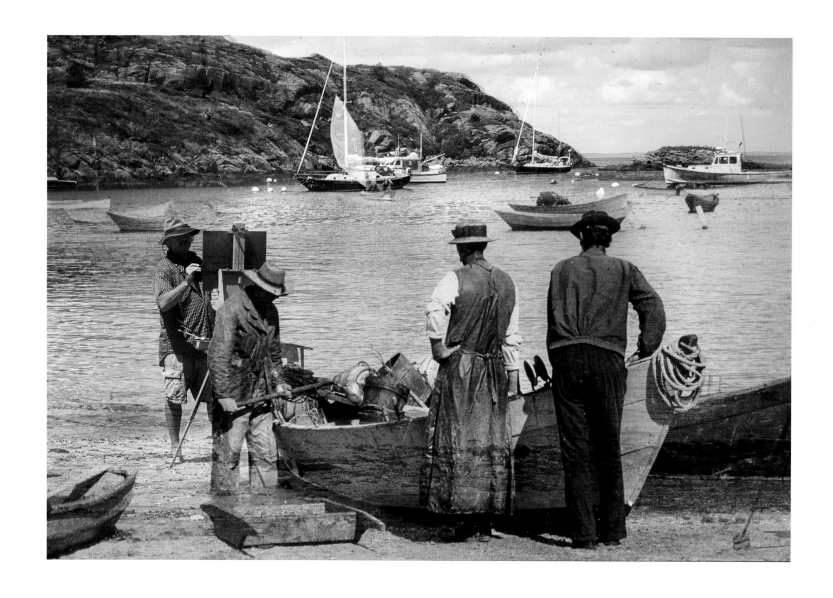

The Day's Catch

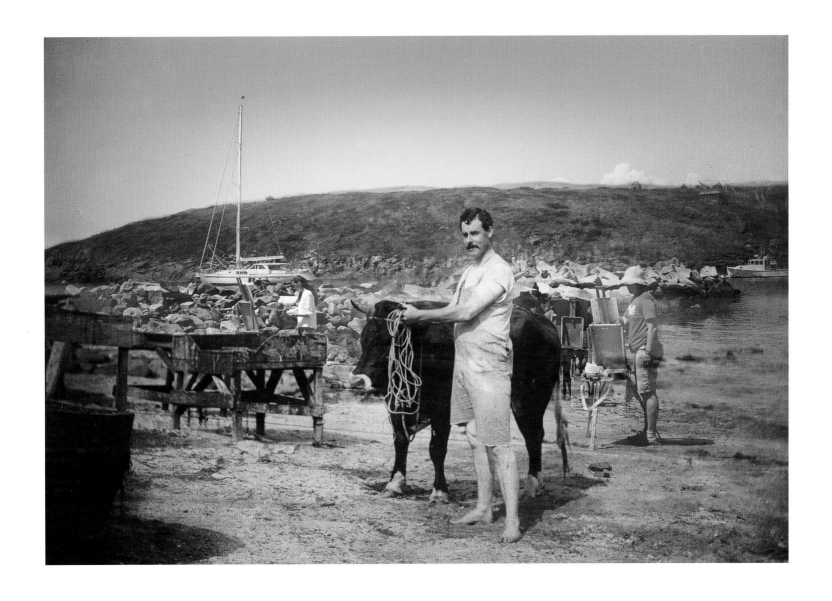

Ox on Beach

In 2013, year-round resident painter Alison Hill posed where Edward Redfield painted the dock scene from below the Island Inn in 1928.

Every summer morning at 8:30, Hill trucks by in her sandals and shorts, hauling her garden cart, on the way to paint. In the afternoon she is back in the studio, welcoming a stream of visitors, collectors, and admirers. The complexities of the artist's life are hidden—procuring supplies, stretching canvas, arranging shows, framing; selling and marketing. Turpentine. Clean shorts. (The photo release she signs bears a finger-smudge of red paint.) Her cart is loaded with easel and paintbox, lunch and layers of clothes, brushes and rags. The tires on the cart need to be kept inflated. In the winter, she stuffs old paintbrushes in the cracks around the chimney, scant bristles of insulation against the gales.

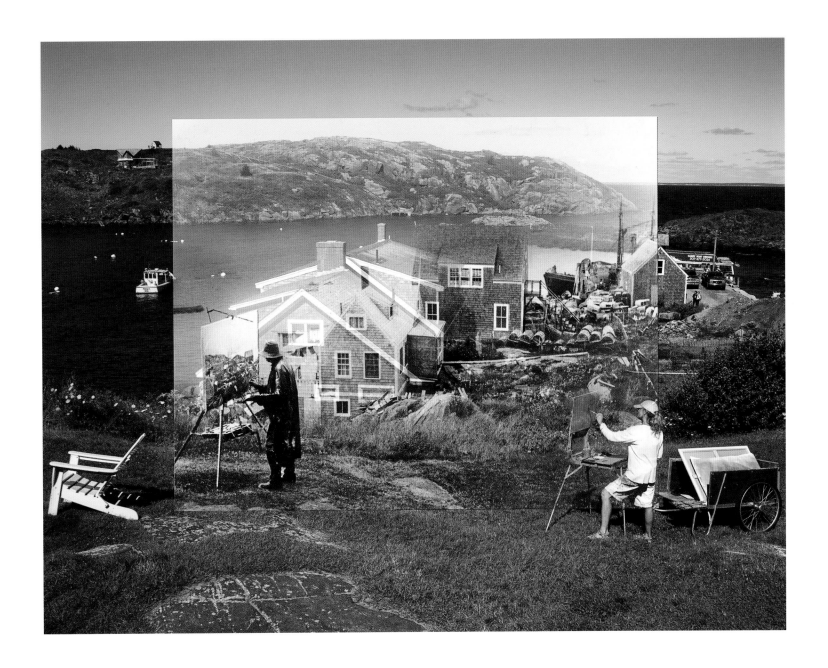

Redfield & Hill

The same day in 1928 that Redfield painted the dock, Mary Townsend Mason stood on the porch of the Island Inn and painted Redfield painting the dock, and was recorded by the same photographer. Late in 2013, Mason's granddaughter, Sandra Mason Dickson, who has a studio on the island, "joined" her grandmother on the porch.

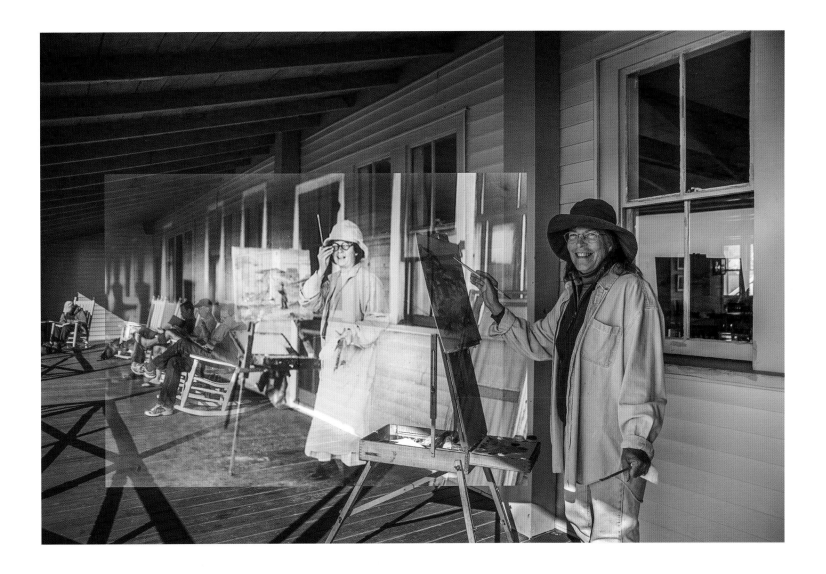

Grandmother and Granddaughter

THE VILLAGE

The village may resemble a theme park in the summer, but the tiny year-round community always lies at its heart. It is a heart that beats in every season.

In 1914, the year-round community on Monhegan numbered 130; it had peaked at 195 in the census of 1860. As of this writing, the year-round community is down to 45—officially. The only store that had been open year-round closed at the end of 2013. Lobster landings are at record highs, prices at record lows; only eight boats started the lobster season in 2013. When the summer's thousands arrive, the dozen or so families and the small legions of summer workers haul at multiple jobs a day.

"An invitation to eat out," said an exhausted sternman, "that's gold out here."

The island and its people endure. That same sternman is going to run the new community store, opening in 2014—and continue to fish, likely. Her family came to Monhegan more than a century ago.

The last few years have seen the birth of the Farm Project and a Farmers' Market that seek to increase the sustainability of island life. The island is advertising on the mainland for more young families to take advantage of the unique, progressive island school system. There are wind turbines on the horizon, both literally and figuratively.

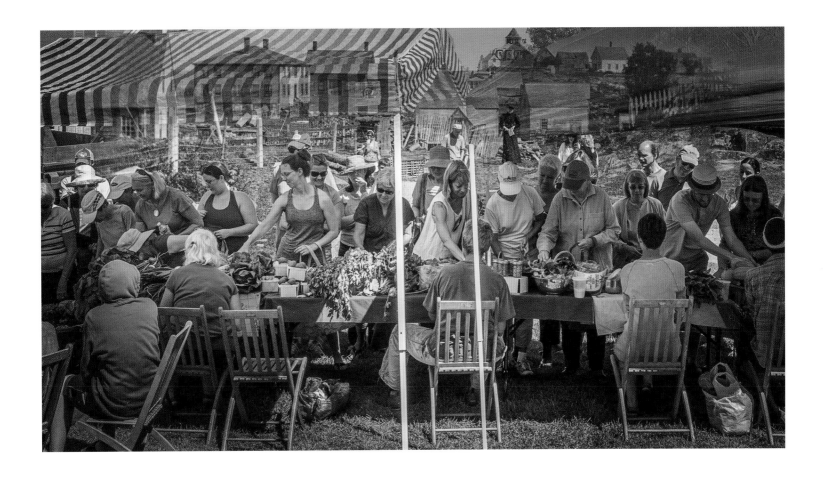

The Farmers' Market

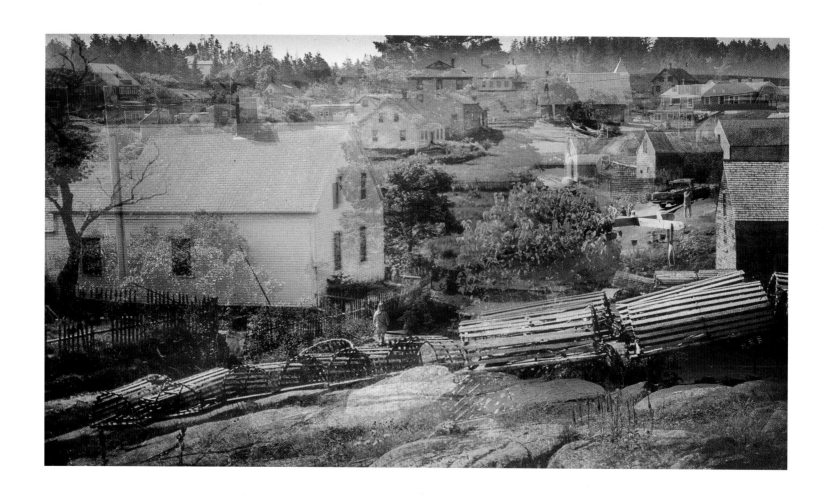

Village South

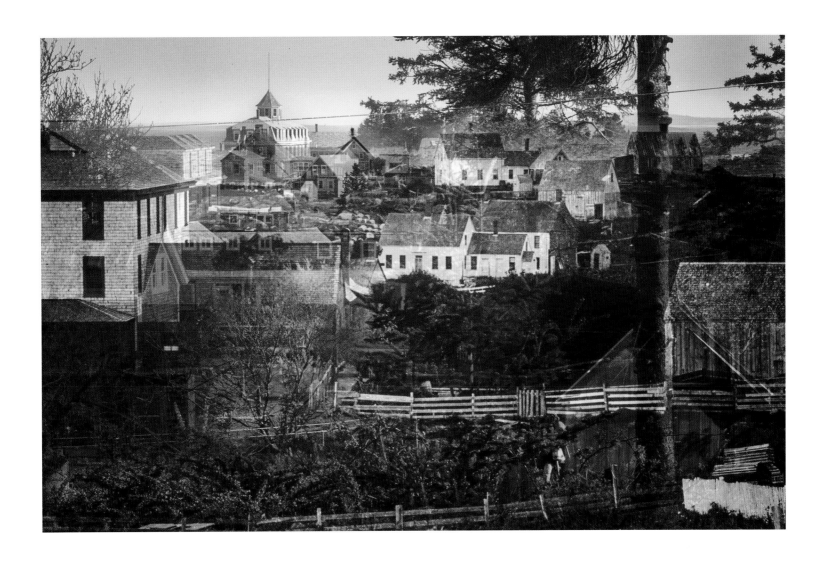

The View from Triscott's House

Midweek in January, it snows overnight, four inches of light powder and, remarkably, no wind. Right now there are only thirty people on the island, three of us from "away." Each of us leaves tracks. The tire tracks of the first truck to the dock at five a.m.; boot prints in snow, then sand, where two lobstermen dragged their skiff to the water; the dogs and cats on their morning rounds—only a dozen dogs at most, they all can be mapped; the muskrats by the meadow, the pheasant on the cliff, the tracks of the postmaster going up the post office steps, children going to school by sled pulled by mom.

The islanders see my tracks as well. I do not belong here, and the simplicity of winter dramatizes that fact. They cannot help but suffer intruders and, if they must, take us in. I have to respect their privacy, where there really is none. At night you can see the lights of two or three houses. You can hear a voice clear across the village.

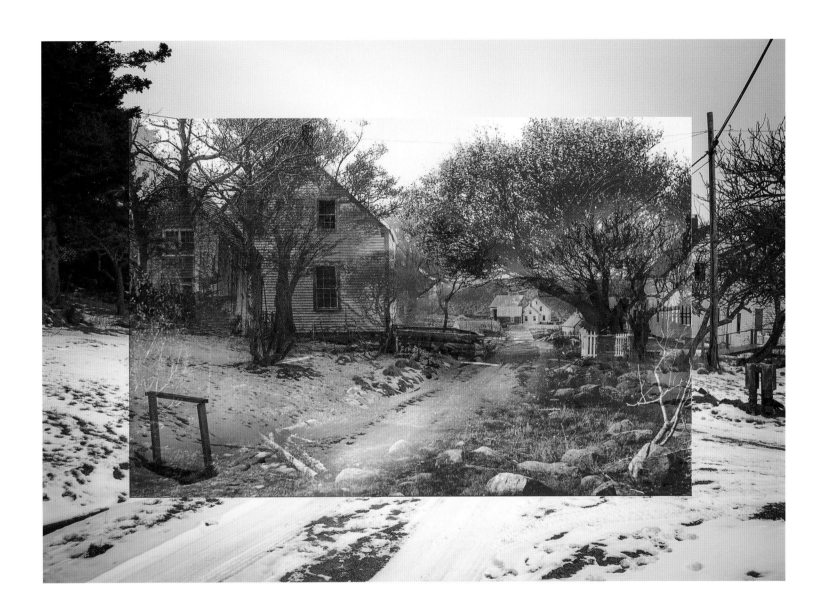

Reuben Davis House

In an islander's home I get a glimpse of island family life. "We had breakfast, lunch, and dinner at this table, every day," says one Monhegan father. The school is a stone's throw away. But there is no junior high or high school here, and this family's sons are now at boarding school on the mainland.

Everyone is called by first name on the island. To the students and parents, the teacher's name at the island school is "Mary." After the seventh-grader goes to the mainland, his father asks him his new teacher's name. "I don't know," says the boy, puzzled. "I call her Mrs. Moulton."

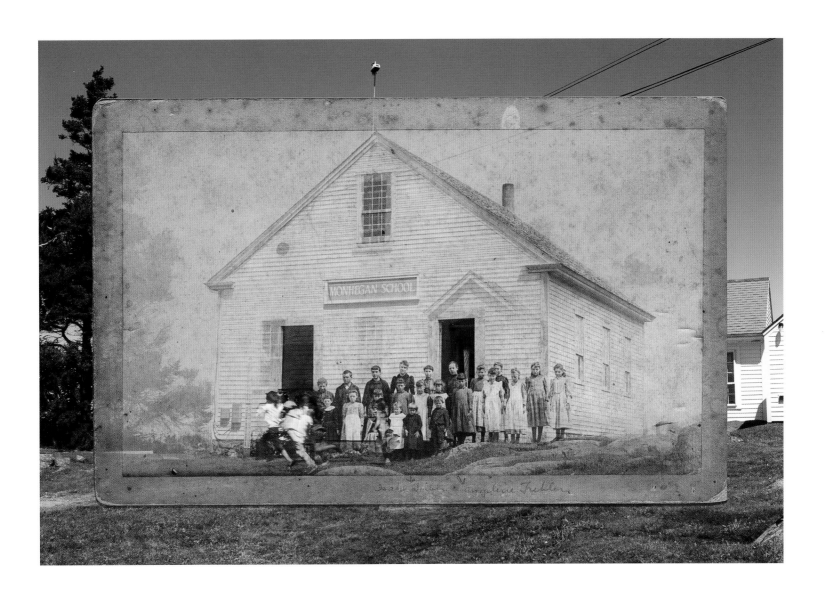

Monhegan School

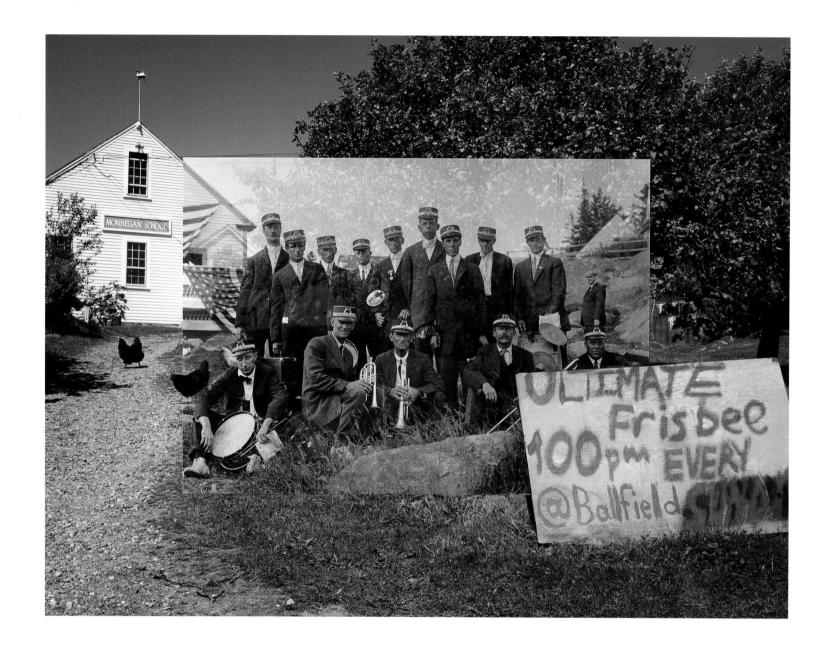

The Cornet Band

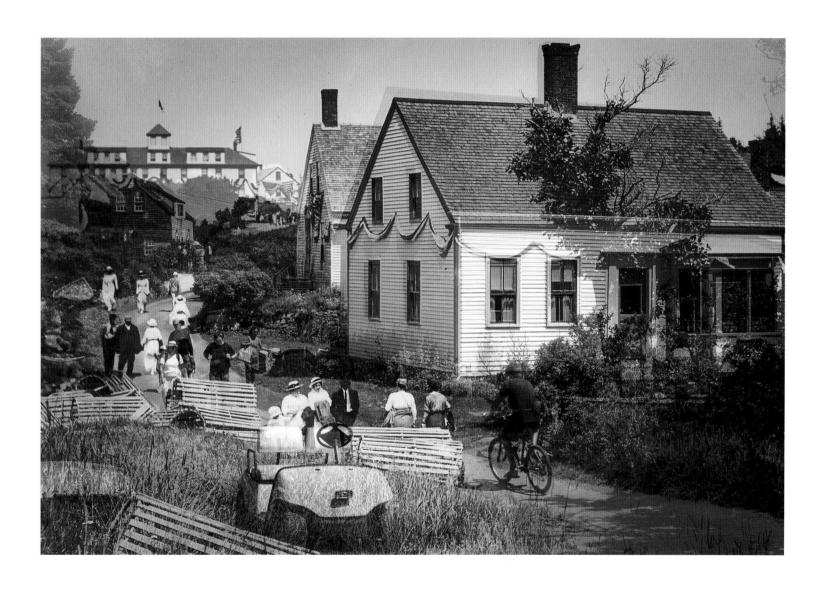

Passing By

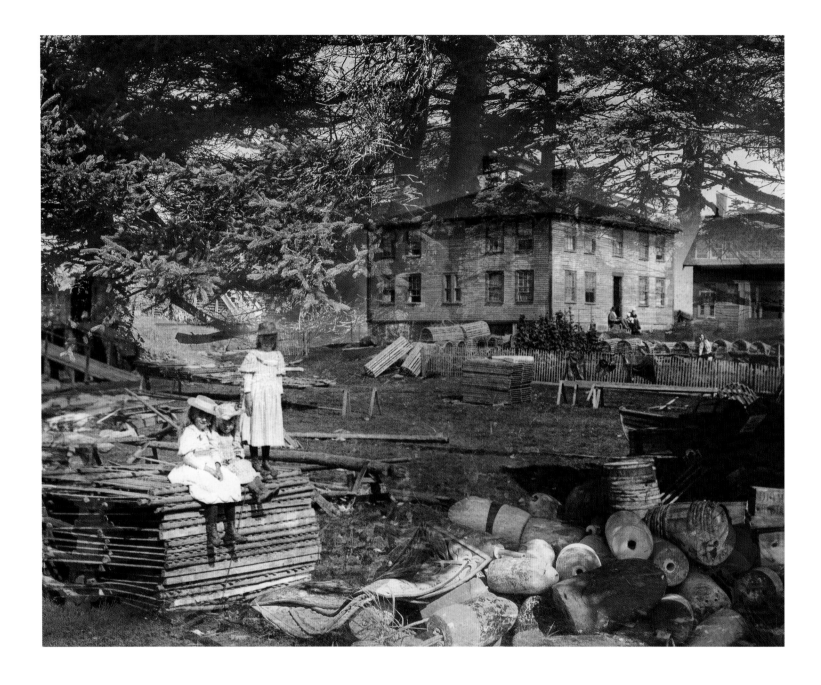

Three Girls Under "The Influence"

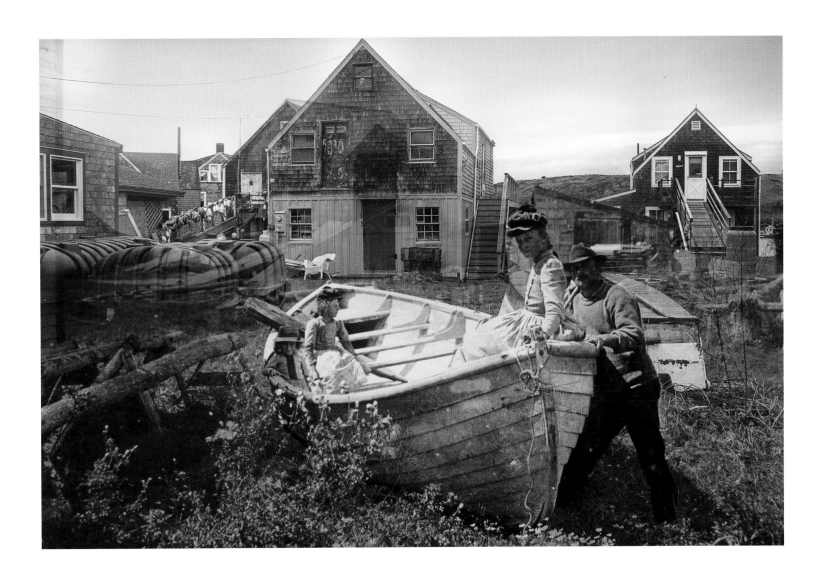

The Dory

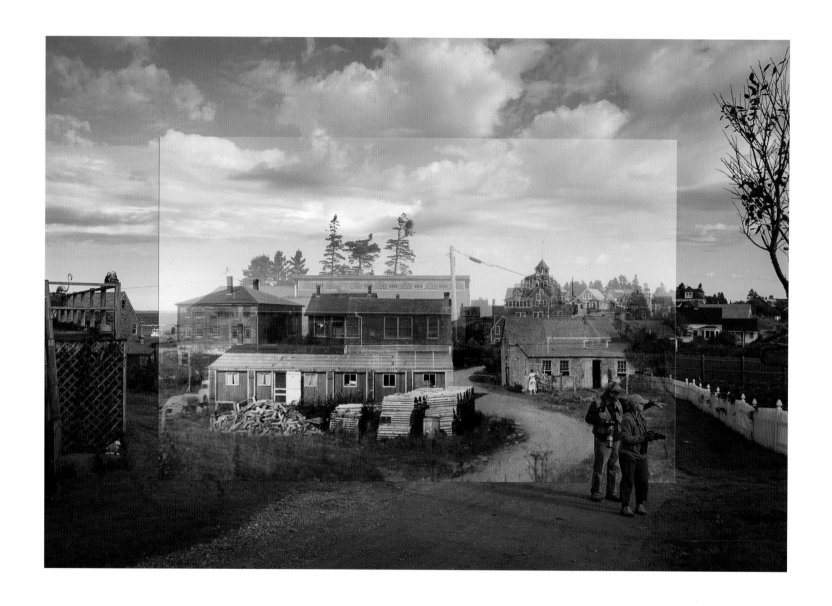

Birding Monhegan

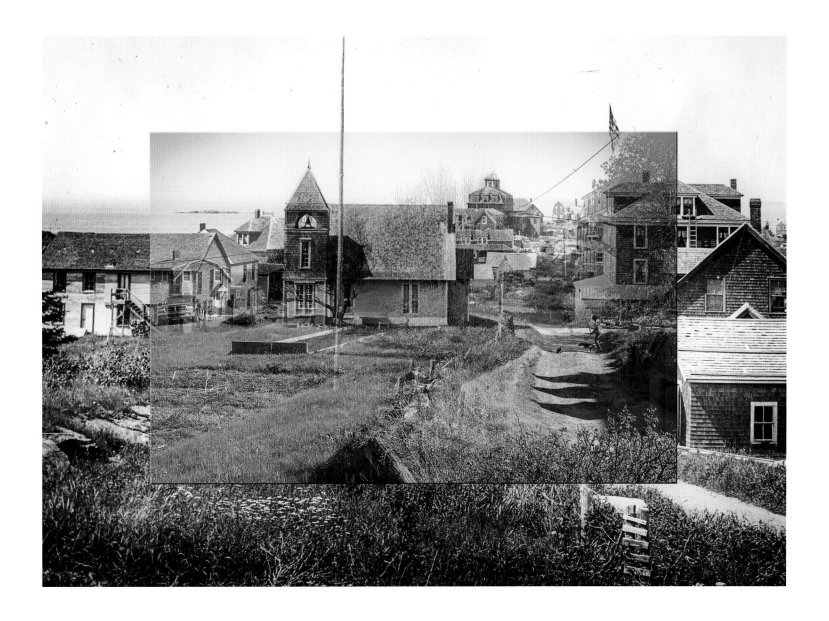

Church, Cat, Dog

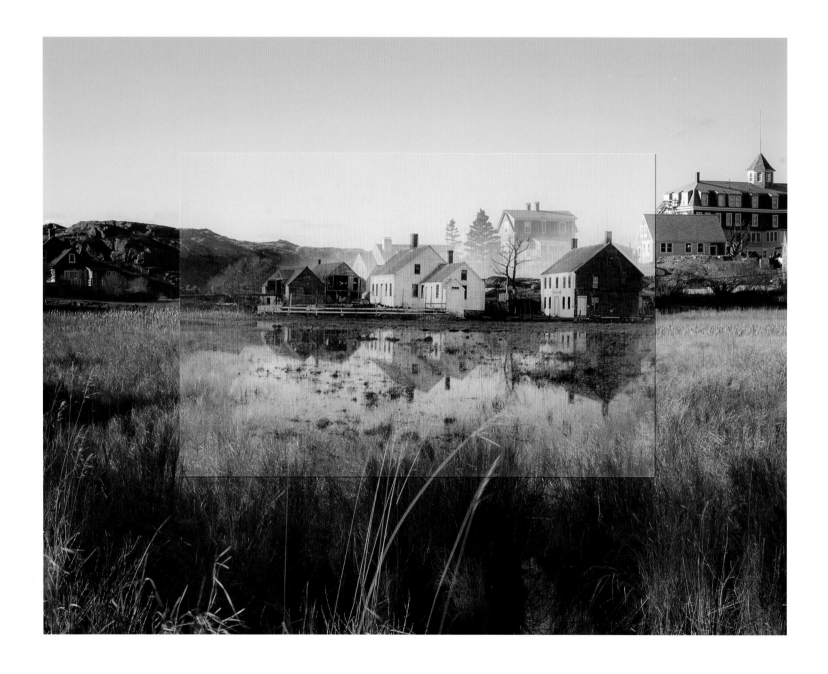

Across the Meadow

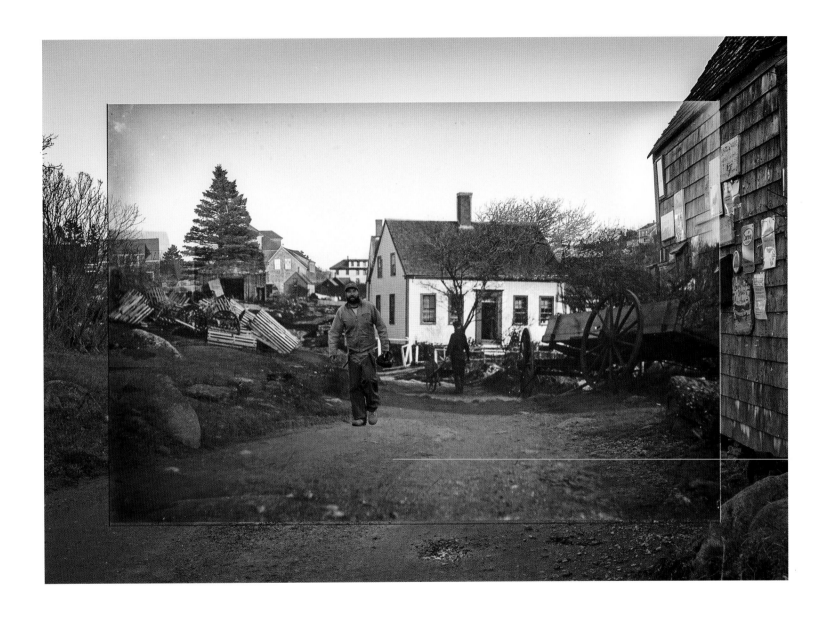

The Workmen

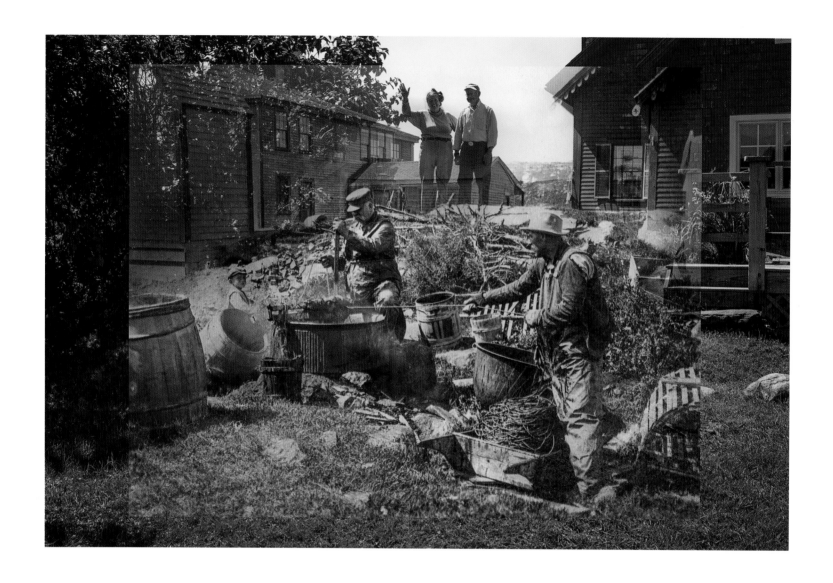

Farewell to Tarring Rope

We celebrate the past, I think, to say goodbye again. Revive the ghosts in order to put them to rest. Go back over time—another hundred years, or a thousand—and the past disappears entirely. In the meantime, we remember.

I loved making these images of Monhegan. I loved the encounters, the surprises, the gradual revelations. I have also loved seeing and hearing people respond to the images, looking closely. This book ends with one such response.

I did not know Iris Miller, Monhegan poet, when I photographed her striding past the library more than a year ago. But a few weeks before this book was to go to press, she sent me the poem that appears on the following page, and provided the final word.

A COMPOSITE PHOTO

The photographer caught me unaware
as I trudged up the slope by the school
on the island, clutching the strap of my bag
in one hand, a walking stick with the other.
Sunlight illumines my face, throws my long shadow
across the dirt road. Behind me, the library's
Adirondack chairs float over the meadow
unmoored—the library not yet built, the children
for whom it will be named not yet drowned.

Oxen hitched to a wooden cart are prodded
by a man in a cap and vest, while birders gather
in the distance, wearing jeans and Gore-Tex,
binoculars trained on a barren field
that will someday be lush with lupine.
If I could just look hard enough, I might see
others, too—Doug and Harry, Rita, Teco
Alta, Vernon, Harry T—half-concealed
among grasses and leaves, as on the old calendars.

As for me, I am approaching the photograph's
edge. Already I am becoming
diaphanous—a rocky ledge can be seen
through my hair, an iron pipe on the ground
shows through my thick wool coat. I am looking
down at the road, frowning, or squinting
in the sun, thinking perhaps of the hill ahead
which will get steeper before it levels off.
But by then I'll be out of the picture.

Iris Miller

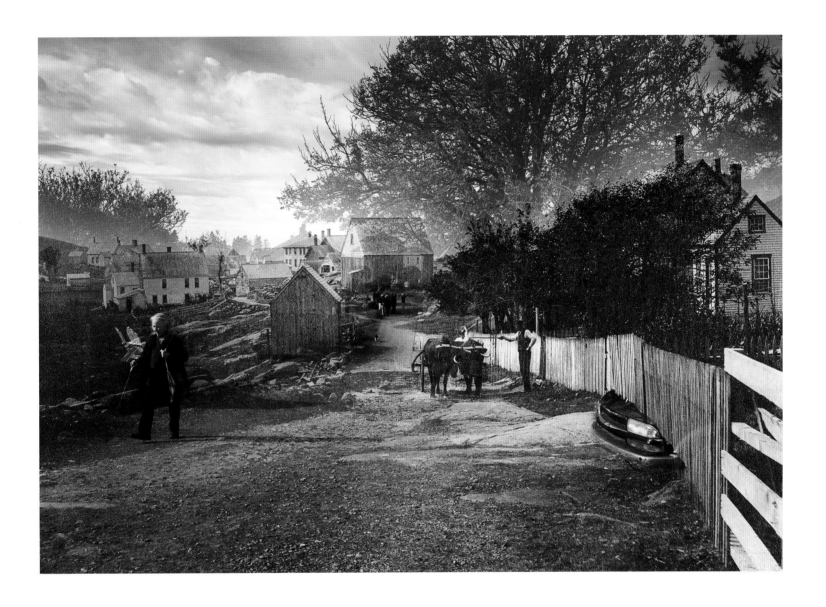

The Road

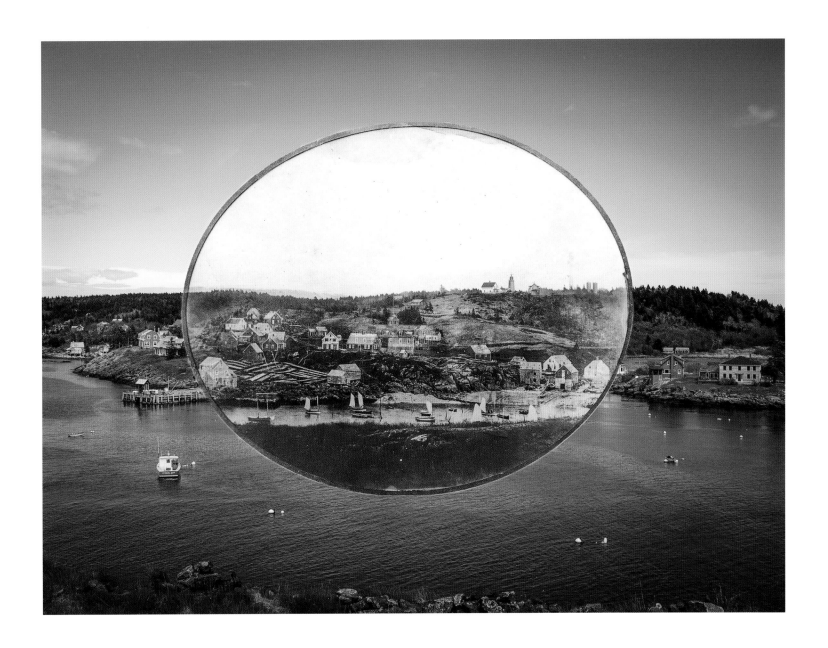

1874 Daguerrotype, oldest known photographic image of the island

ACKNOWLEDGMENTS

Many of the vintage photographs used in this album were made by S. P. Rolt Triscott, a British watercolorist and photographer who discovered Monhegan Island in 1892 and lived there until the end of his life in 1925. I came upon Rolt Triscott's work—and the inspiration for this project—through the book *Discovering S. P. Rolt Triscott*, by Richard H. Malone and Earle G. Shettleworth, Jr. I learned that Triscott was born in 1846, exactly one hundred years before I was born. He attended and exhibited his work at the tercentennial celebration in 1914.

I am grateful to our friends Jeff and Sarah Flause, who got us to Monhegan in the first place. My wife Emily has been a constant and patient believer in the work from day one, and an avid critic in all the best senses—and she took care of the chickens when I was away.

The Monhegan Museum was extraordinarily generous, giving me access to the scans of their collection of vintage photographs in order to undertake a project that would honor the quadricentennial and raise funds for the Quadricentennial Committee. My thanks especially to Jenn Pye, islander and curator.

Nearly all the year-round residents, too many to name, touched this work one way or another; many offered essential help, wisdom, and encouragement. Special thanks to Kathie Krause, old soul, who put me up in the winter and was my guide to the spirit of Monhegan. I'm glad to share our chickens with you.

A number of Monhegan artists offered insight and encouragement; and Alison Hill, Frank Bruckmann, and Sandra Mason Dickson willingly took part in the few posed pictures. Photographer and master compositor Douglas Prince, designer Michael Mahan, Maine State Historian Earle G. Shettleworth, Jr., poet Iris Miller, and editor Lois Shea brought their skills and interest to the project—and turned my hopeful skiff into a more graceful vessel.

R.W. M.